LIMOGES

ENAMELS

at

THE FRICK COLLECTION

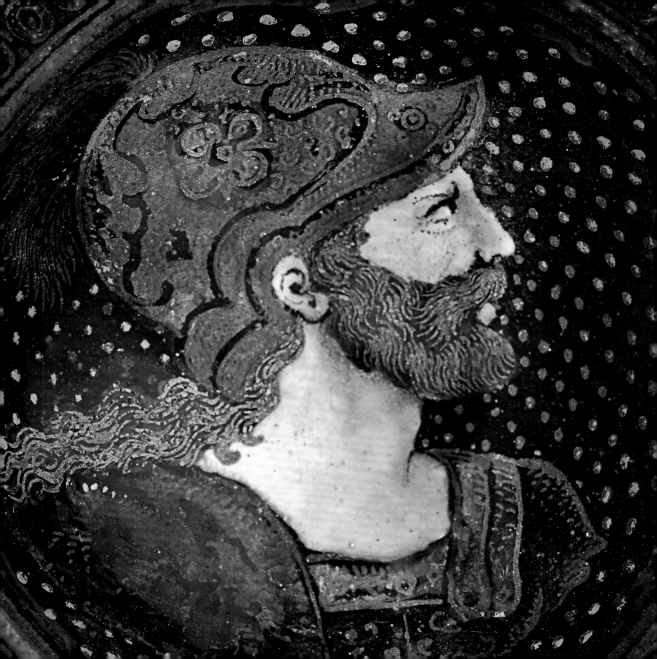

LIMOGES
ENAMELS
at
THE FRICK COLLECTION

Ian Wardropper with Julia Day

The Frick Collection, New York, in association with
D Giles Limited, London

For Sarah
— I.W.

ISBN: 978-1-907804-37-3

Published by The Frick Collection
in association with D Giles Limited

The Frick Collection
1 East 70th Street
New York, NY 10021
www.frick.org

D Giles Limited
4 Crescent Stables
139 Upper Richmond Road
London SW15 2TN
www.gilesltd.com

For The Frick Collection:
Michaelyn Mitchell, Editor in Chief
Hilary Becker, Assistant Editor

For D Giles Limited:
Designed by Alfonso Iacurci
and Helen McFarland
Copyedited and proofread
by Sarah Kane

Printed and bound in Hong Kong

Photography of all works in
The Frick Collection is by
Michael Bodycomb.

Front cover: Detail of no. 18
Back cover: Detail of no. 3
Frontispiece: Detail of no. 38
Opposite: Detail of no. 10
Page 6: Detail of no. 29
Page 24: Detail of no. 36

Library of Congress Cataloging-
in-Publication Data

Wardropper, Ian, author.
Limoges enamels at the Frick Collection /
Ian Wardropper with Julia Day.
 pages cm
Includes bibliographical references and
index.
ISBN 978-1-907804-37-3
1. Frick Collection--Catalogs.
2. Enamel and enameling, Medieval--
France--Limoges--Catalogs.
3. Enamel and enameling, Renaissance--
France--Limoges--Catalogs.
4. Enamel and enameling--New York
(State)--New York--Catalogs. I. Day, Julia
(Julia Berniece), author. II.
Frick Collection, issuing body. III. Title.
NK5004.F8F75 2015
738.4074'7471--dc23
 2015008026

Note to Reader:
Unless otherwise indicated, the medium
for each object is painted enamel on
copper, partly gilded. The order is, for
the most part, chronological, with some
objects grouped by artist or workshop.

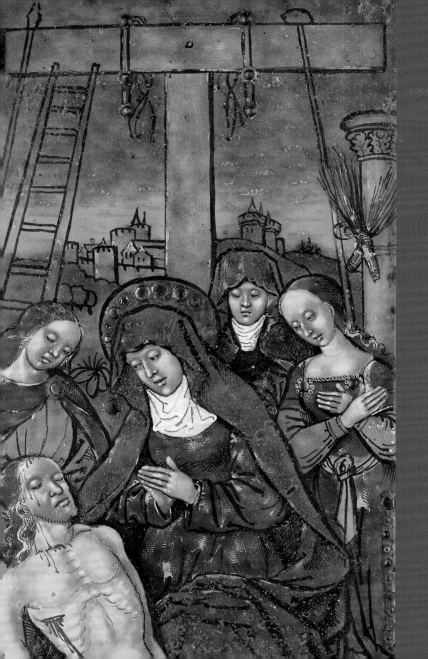

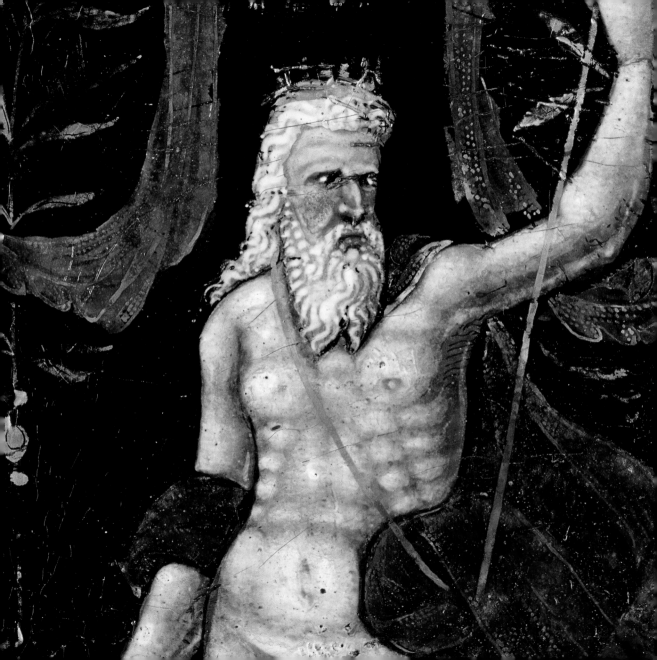

INTRODUCTION

Ian Wardropper

In 1916, two years after moving into his newly constructed mansion in New York, the industrialist and collector Henry Clay Frick vacated his personal office to make room for a collection of painted enamels (fig. 1).[1] What was so compelling about these small sixteenth-century works, his latest acquisitions, that their owner was willing to sacrifice his sanctuary for their display?

Collecting decorative arts had come late in Frick's life. When he moved, in 1905, to New York from Pittsburgh, where he had made his fortune in coke and steel, his passion was the hunt for Old Master paintings. Crowning this activity was the West Gallery of the house he was building on Fifth Avenue, which would be the largest private space for showing paintings in the city. As plans for the house developed, Frick acknowledged the need to furnish it with works of art comparable to his paintings; and so he set out to acquire them. Italian Renaissance chests (cassoni), French eighteenth-century marquetry and veneered furniture, and Sèvres porcelain began to enter the collection.[2]

Frick's collection of enamels was actually assembled by the American financier and art collector John Pierpont Morgan (1837–1913).

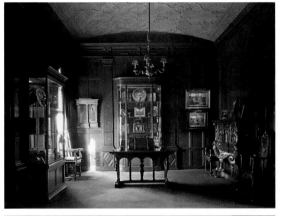

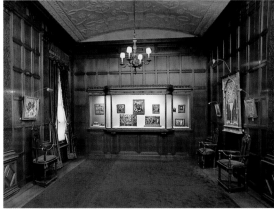

Fig. 1. The Enamels Room, 1930 and present day

In the first decade of the twentieth century, Morgan purchased the enamels from several art dealers, including Murray Marks, a partner in Durlacher Brothers, and Charles J. Wertheimer, both in London; the French art dealer Jacques Seligmann; and Duveen Brothers in London, New York, and Paris. The collection rapidly became one of the most important of its kind in private hands and was on loan to the Victoria & Albert Museum until 1912.[3] In orchestrating the dispersal of Morgan's extraordinary collection, Joseph Duveen played an important role in the selection of the objects for his clients. His promise to Frick that he would receive the best examples of Italian Renaissance bronze sculpture and French Limoges enamels was confirmed by Frick in a letter to Duveen in May 1916: "The essence of our understanding . . . was, I was to have all the finest bronzes and Limoges in the collections purchased by you from the Estate of J. P. Morgan." With forty objects purchased in June 1916 at a total price of $1,157,500, Frick acquired the most important group, in number as much as in value, of Morgan's enamels.[4] A year earlier, in February 1915, Frick had purchased *The Progress of Love,* a series of paintings by the French eighteenth-century master Jean-Honoré Fragonard, for $1,250,000, by far his most expensive acquisition to date. In April 1915, he had acquired Giovanni Bellini's Renaissance masterpiece *St. Francis*

in the Desert for $170,000. Clearly, the collector was willing to pay an exceptionally high price for the enamels.

Limoges enamels—named for the French town in which they were produced—had attracted great French connoisseurs. From the beginning of the nineteenth century, names like Paul Durand-Ruel, Pierre Révoil, and later Alexandre-Charles Sauvageot and Alexandre Du Sommerard found their way into the provenance of many works that entered the Parisian museums of the Louvre and Cluny and later the Musée National de la Renaissance, housed in the Château d'Écouen.[5] Other important collectors included Frédéric Spitzer, Prince Basilevski, Émile Gavet, Edmond Foulc, Louis Fidel Debruge-Dumenil, and several members of the Rothschild family. In England in 1871, Sir Richard Wallace purchased a number of enamels to add to those he had inherited from his father.[6] (Frick's visit to the Wallace Collection in 1913 inspired many subsequent acquisitions of decorative arts.) Baron Ferdinand de Rothschild's gift to the British Museum in 1898, known as the Waddesdon Bequest, and George Salting's 1909 gifts of funds and objects to the Victoria & Albert Museum established significant holdings of enamels in these London institutions.[7] Morgan and Henry Walters in Baltimore were among the first to collect Limoges in America. When Frick was acquiring his enamels, fellow American collectors included William

Randolph Hearst (whose works are now in the Los Angeles County Museum of Art), Philip and Robert Lehman (The Metropolitan Museum of Art), Peter A. B. Widener and his son Joseph (Philadelphia Museum of Art), and Charles Phelps and Anna Sinton Taft (Taft Museum, Cincinnati).[8] Along with museums in London, Paris, and a few other centers, The Frick Collection stands today as one of the major museums housing important Limoges enamels. Representing most of the notable artists and covering many characteristic types and subjects, this New York collection constitutes a comprehensive survey of painted enamels at a distinguished level of quality.

THE MAKING OF MEDIEVAL AND RENAISSANCE ENAMELS

Enamels are composed of powdered glass fused to a metal substrate. Created by adding metal oxides to clear glass when molten, color is affected by both the composition of the glass and the concentration of the metal oxide used, as well as the atmospheric conditions in the kiln. Copper oxide mixed with an alkali glass composition, for instance, yields a translucent blue, but green is produced when it is combined with lead glass. An artist's palette is restricted to those materials that can survive high temperatures in the kiln. Medieval enamels were generally created using opaque colors such as white, black, green, blue, yellow, and red. Translucent

colors were also used, typically on top of gold or silver, which allowed the surface below to reflect light.[9]

In the metalworking centers along the Meuse River in Germany and in Limoges in the twelfth through fourteenth centuries, colored enamels were applied to surfaces principally by one of two techniques, cloisonné and champlevé. In cloisonné, metal strips called cloisons are attached to the metal substrate, forming raised cells.[10] In champlevé, recessed areas are gouged or cast into the metal surface (fig. 2).[11] The raised or recessed areas, which prevent the different colors from flowing into one another, are then filled with enamel. Also during this period, translucent

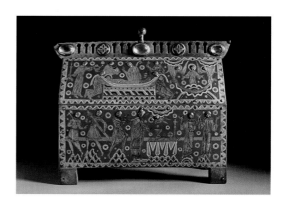

Fig. 2. *The Becket Casket*, ca. 1180–90. Copper alloy, champlevé enamel, crystal, glass, wooden core, 11 ⅝ × 13 ⁹⁄₁₆ × 4 ⅞ in. (29.5 × 34.4 × 12.4 cm). Victoria & Albert Museum. © Victoria & Albert Museum, London

enamels were often applied to precious metals with chased designs, creating jewel-like tones in a technique known as *basse-taille*.

In the Middle Ages, the production at Limoges centered on liturgical vessels such as pyxes and reliquaries, fostered by the city's location on pilgrimage routes to sites of devotion in Spain and Italy and its proximity to monasteries that were wealthy patrons of the art. The Limoges workshops also made domestic items like caskets and basins, as well as jewelry, belt buckles, and other objects for personal adornment that were prized throughout Europe.

Sixteenth-century Limoges enamels have their roots in the Middle Ages but were unmistakably a Renaissance phenomenon. Most distinctively, they were painted on flat or curved copper substrates—often rectangular—rather than executed in cloisonné or champlevé. The metal cloisons, or shallow depressions that formed the strong designs of medieval works, disappeared as enamelers learned new methods for visually separating colors; instead, these enamels were more like miniature paintings on panel or paper. Early in the sixteenth century, the metal plates were hammered into slightly convex shapes to minimize warping during heating and cooling. The front of the metal plate was coated with a ground color on which successive layers of enamel were applied; and a counter-enamel was applied—though less meticulously—to the back. In earlier Limoges

enamels, the lines of the composition were put onto a white ground in black or red oxide colors; barely raised over the surface, these lines established the design and helped to separate the subsequent application of colored translucent enamels, which overlapped on the dark lines. The enamels were fired multiple times, and enormous skill was required to control the different temperatures necessary for the various colors and layers.[12] Sometimes pieces of silver or gold foil, called paillons, were applied below the translucent enamels to achieve a rich encrustation. Paillons could also underlie larger areas, such as drapery, to produce glowing colors.[13]

Techniques developed during the fifteenth and sixteenth centuries permitted a wider range of opaque and translucent colors. Enamelers increasingly exploited the overlay of one color on another in thin layers or, with subtle shading, manipulated them to reveal what lay beneath. For instance, to achieve a more naturalistic flesh tone, early enamelers sometimes applied mulberry beneath the white to create warm undertones. *Enlevage* was also employed to enhance details in the composition, or grisaille was used to produce subtle modeling in shades of gray. Final touches of oxide color or gilding, brushed on and lightly fired, added expression and a luxurious glow.

The painted enamels of Limoges constitute one of the distinctive art forms of the French Renaissance, but their production remained largely regional.[14] Much of what

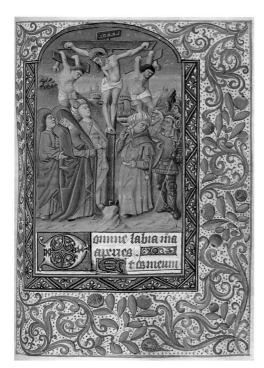

Fig. 3. Master of the Orléans Triptych (?),
*Book of Hours for the Use of
Limoges*, 1480–1500. Manuscript,
8 ½ × 5 ½ in. (21.5 × 14 cm). The Art
Institute of Chicago (1915.540).
© The Art Institute of Chicago

characterizes art of the period—such as the magnificent interiors of Fontainebleau, the architecture in Paris, and the royal chateaux—centers on the court in the Île-de-France and its outliers. Far from the circle of the king, enamelers in central France revived a local practice, refining and improving earlier methods. While commissions often came from elsewhere and some enamelers, notably Léonard Limousin, were active at court, the strength of the Limoges production came from the technical achievements and the high level of skill of the city's tight circles of artisans.

SOURCES

The imagery in enamels was largely inspired by other art forms. The subject of *The Seven Sorrows of the Virgin* plaque attributed to the workshop of Pierre Reymond (no. 22) appeared in French manuscript illumination as early as the fourteenth century. The book of hours of Perrenot de Granvelle of 1532 depicts scenes of the Seven Sorrows in roundels, each showing a sword extending from the perimeter and aimed at the Virgin's heart. The following year, the workshop of Pierre Reymond adopted this motif for an enamel.[15] The plaque's small size recalls the intimate scale of a prayer book. The Master of the Orléans Triptych's Crucifixion scene (no. 1) so closely follows an illuminated book of hours belonging (by 1510) to the Limoges consul's wife (fig. 3) that it is possible

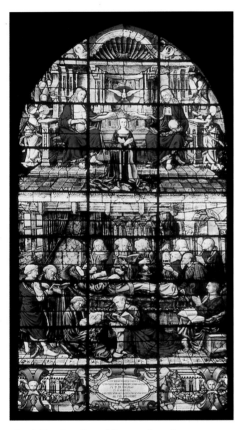

Fig. 4. *The Death and Coronation of the Virgin*, ca. 1510–20. Stained glass, 244 ⅛ × 118 ⅛ in. (620 × 300 cm). Église Saint-Pierre-du-Queyroix, Limoges. © Région Limousin. Service de l'inventaire et du Patrimoine culturel. Frédéric Magnoux. Claude Tibaudin. 1984

he painted the manuscript illuminations himself.[16] Works of art of far greater scale also influenced enamels. A stained-glass window in Saint-Pierre-du-Queyroix, Limoges (fig. 4), for instance, shows the Virgin crowned by God the Father and Christ Pantocrator, a motif adopted by an enameler in the workshop of Nardon Pénicaud for a triptych that includes the Coronation of the Virgin (no. 5).[17] It is not surprising that the glass panels of local churches attracted the attention of enamelers, who were able to apply translucent enamel colors to copper. Another source, if indirectly through prints, was oil painting. Agnolo Bronzino's *Adoration of the Shepherds*, painted in 1530–40 for Filippo d'Averardo Salviati (now in the Museum of Fine Arts, Budapest), served as an exact model for the plaque by Master IDC (no. 37) of the same subject from the late sixteenth or early seventeenth century.[18] Since it is unlikely that the Limoges artist ever visited Florence to see the original, he probably made his enamel after engraved copies of the painting by Giorgio Ghisi (1554) and Cornelis Cort (1568). These found their way to France and supplied the Latin inscription faithfully reproduced by the enameler.

The interpretation of a famous Florentine painting by Master IDC in Limoges was only possible through the intermediary of printmaking. An important factor in the emergence of this provincial city into a specialized artistic center was the increasing availability of printed sources.

Printed books, woodcuts, engravings, and etchings began circulating in the cultural capitals of Europe in the fifteenth century and were widely accessible by the mid-sixteenth century.[19] Enamelers rarely invented their subjects but rather adapted existing designs, often combining motifs from multiple sources into a single composition, and skillfully created brilliantly colored works of art from their generally black-and-white sources. German prints had an enormous influence on enamelers early in the sixteenth century. For example, Jean Pénicaud I relied on an engraving by Martin Schongauer (fig. 5) for the composition of his *Christ Crowned with Thorns* (no. 8). The source for the *Flagellation* on the same triptych is one of the images in Albrecht Dürer's Large Passion series.

Later in the century, favorite models for religious subjects were the woodcuts and engravings of Bernard Salomon (ca. 1508–after 1561) published as illustrations for *Bibles moralisées* in his native Lyon. Primarily representing scenes from the Old Testament, these books made the private imagery of illuminated manuscripts available to a wider public, explicating the scenes through descriptive texts. Salomon's engravings for Claude Paradin's *Quadrins historiques de la Bible* (1553, new edition in 1555) also found enormous popularity.[20]

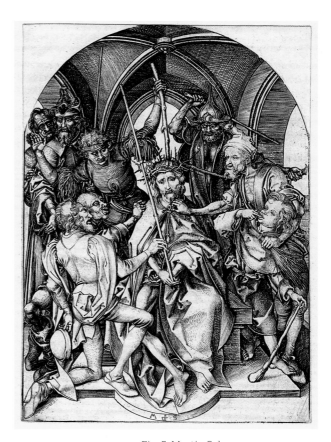

Fig. 5. Martin Schongauer, *Christ Crowned with Thorns*, 1470–82. Engraving, 6 5/16 × 4 1/2 in. (16.1 × 11.5 cm). The British Museum. © Trustees of the British Museum

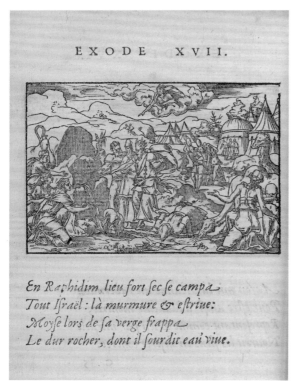

EXODE XVII.

En Raphidim, lieu fort fec fe campa
Tout Ifraël : là murmure & eftriue:
Moyfe lors de fa verge frappa
Le dur rocher, dont il fourdit eau viue.

Fig. 6. Bernard Salomon, *Moses Striking the Rock*, 1553. Woodcut reproduced in the *Quadrins historiques de la Bible* (published in Lyon by Jean de Tournes), 6 ⅛ × 3 ⅞ in. (15.5 × 9.8 cm). Bibliothèque nationale de France

Master IC used Salomon as his guide for two cups (or tazze) featuring religious subjects. In *Moses Striking the Rock* (no. 35), he adapted the rectangular woodcut from *Quadrins historiques de la Bible* (fig. 6) to a round format by focusing on the stiff-armed Moses miraculously creating a spring and by repositioning a dog and a crouching man to fill out the circular perimeter. In a companion cup (no. 36), he foregrounds Salomon's figures of Lot and his daughters and completes the roundel with scenes—Lot's wife turned into a pillar of salt, the burning city of Sodom, the cave overhung by trees—from engravings by Philip Galle (1537–1612) that he may have known through the work of other enamelers.[21] Salomon's illustrations were the basis of numerous enamels, including many in The Frick Collection, such as the plaques on two caskets by Pierre Courteys, *Old Testament Subjects* (no. 20) and *Scenes from the Story of Joseph* (no. 21).

Although Bernard Salomon's compositions were mainly of religious subjects, his *Métamorphose d'Ovide figurée* (published by Jean de Tournes in Lyons, 1557) supplied ideas for enamels subjects drawn from classical mythology, which became increasingly popular in France in the mid-sixteenth century. Suzanne de Court's late sixteenth-century saltcellars depicting the story of Orpheus (no. 38), for example, adapt the scene of Orpheus

playing his lyre to a unicorn and a lion from Salomon's *Métamorphose.*[22] For the gods and goddesses interspersed with the Labors of Hercules on a pillar candlestick (no. 34), Master IC borrowed from French printmaker Étienne Delaune and German engraver Heinrich Aldegraver, respectively. The Limoges enamelers creatively transformed these printed images into the colors and shapes of a different medium. Master IC brilliantly translates Delaune's and Aldegraver's inked lines into supple and subtly shaded bodies while artfully stretching them over the convex bases surrounding his candlestick. Another source for Master IC was Francesco Pellegrini's *La Fleur de la science de pourtraicture* (Paris, 1530), which he consulted for the template of the interlace design that circles the shaft of his pillar candlestick (no. 34). This type of arabesque decorated the surfaces of many French Renaissance art forms—from the ceramics of Saint-Porchaire to the interiors of the Galerie François I at Fontainebleau.

The grotesque, which originated in Renaissance artists' copies of ancient wall paintings unearthed in Rome or Pompeii, was another favorite decorative motif. Infinitely variable, grotesques furnish the fanciful stage for Jupiter on the reverse of Jean Reymond's oval dish (no. 29). Beneath a canopy in a hanging niche and flanked by donkey-eared monks on spiraling supports, the chief Olympian stands astride his eagle while scrolls, birds, vases, and other curious motifs fill out the background. Prints by Delaune after Italian sources provided examples for enamelers like Reymond, who delighted viewers with variations of his own devising. Such decorations could be a central motif on the reverse but more often filled the borders surrounding principal scenes on the front.[23]

THE SUBJECTS

The two subjects that captivated the public during the Renaissance were religion and classical mythology. In the late fifteenth and early sixteenth centuries, Christian scenes predominated in the Limoges production and were often incorporated into portable altars. The magnificent double-tiered triptych (no. 7) from the workshop of Nardon Pénicaud follows Christ's life and resurrection through six separate scenes: the Way to Calvary, the Crucifixion, the Descent from the Cross, the Entombment (the largest central scene), the Harrowing of Hell, and the Resurrection. One of the attractions of enamels was that their small size made it easier for the viewer to take in multiple scenes or a continuous narrative all at once. Furthermore, the durable nature of enamel was ideally suited for altars with wings that could be protectively closed to make the object compact and portable. Different versions of Christ's and Mary's

stories are told through enamels in The Frick Collection: the Crucifixion from the workshop of the Master of the Large Foreheads is flanked by the Way to Calvary and the Deposition creating a triptych (no. 2); Jean Pénicaud I depicts Christ Crowned with Thorns flanked by the Kiss of Judas and the Flagellation in his miniature winged altarpiece (no. 8); and an artist in the workshop of Nardon Pénicaud places the Assumption and Coronation of the Virgin on either side of her Death (no. 5). Some single plaques in the collection are known, or suspected, to have been part of a series, as, for example, the workshop of the Master of the Large Foreheads's *Adoration of the Magi* (no. 3), which was once accompanied by two wings (detached and formerly in the Hainauer Collection, Berlin).[24]

The placement of multiple enamels in caskets or portable altars in diptych or triptych form dates back to twelfth-century Limoges though their use to convey a continuous narrative through multiple scenes became more pronounced later. In the Middle Ages, the popular subject of St. Thomas Becket could be seen in many examples of champlevé, with scenes such as his murder in Canterbury Cathedral, his funeral, and his soul being taken to heaven adorning the sides of caskets (see fig. 2).[25] This approach became more common in the Renaissance, whether in

a religious context, as in the casket with the *Story of Joseph* (no. 21) told in eight scenes, or in objects for domestic use, as in a token for a loved one, such as a casket with coordinated vignettes of putti shown in acts of courtly love (no. 11).

Many enamels depict Old Testament subjects. Two episodes from the life of Moses are superimposed on the sides of a ewer by an artist in the workshop of Pierre or Jean Reymond (no. 26). As in a set of tapestries, the sequence of a narrative could be followed from beginning to end on a set of Limoges plaques or around the sides of a single vessel. Compact enough to be held and turned by hand, a Limoges object offered intimate viewing, a very different experience from walking down a hall to follow scenes from one hanging to the next. The vast size of tapestries permitted the inclusion of many details and minor scenes not possible in enamels, the small format of which enabled viewers to grasp the whole subject more quickly.

A preference for series or related compositions is also seen in representations of antiquity. The Twelve Caesars are portrayed within laurel wreaths on ten plaques of a casket; two more plaques show putti leaning on skulls under mottoes reminding us that death triumphs over even the famous (no. 12).[26] In a different strategy, Suzanne de Court required the viewer to fully rotate two saltcellars (no. 38)

to complete the story of Orpheus. On one salt, he is attacked by the Cicones; on the other, his decapitated head is mourned by three women and then rescued by Apollo. The classical gods and goddesses are seen in numerous representations, whether one by one in roundels on a candlestick (no. 34) or in larger compositions, such as *Apollo and the Muses* (no. 31).

Likenesses of oneself, family members, or famous men and women were keenly desired in this period. Following Catherine de' Medici's death in 1589, 341 portraits were recorded in her Parisian house, reflecting the queen mother's interest in having images of notable people from within her kingdom and throughout Europe.[27] Jean Clouet, his son François, and Corneille de La Haye (also called Corneille de Lyon) specialized in drawing and painting portraits on panel. De La Haye would become court painter to King Henry II and subsequently to Charles IX.[28] While many Limoges portraits were miniature (the size of playing cards), others were larger, approaching or equaling the size of the small painted portraits on panel that were prevalent in this era.

Among the Limoges enamelers, Léonard Limousin produced the most portraits—some 130 are known—perhaps because he was so often at court where commissions were readily obtained.[29] As early as 1536, he made a portrait of the Queen of France, Eleanor of Austria. Later he was responsible for some of the largest enameled portraits, such as that of Anne de Montmorency (1556; Musée du Louvre, Paris), which is 18 ⅜ by 22 ¼ inches. Some of the larger ones may have been commissioned by Catherine de' Medici for her *cabinet des émaux* in the Hôtel de la Reine, Paris, which had seventy-one rectangular and oval portraits set into the woodwork.[30]

The Frick Collection has several portraits, as well as a unique group portrait, by Limousin. The portrait presumed to be of Guy Chabot, Baron de Jarnac (no. 14), on the scale of an oil painting on panel, is characteristic of these works. Against a solid dark blue background, Jarnac turns slightly to his right. His sober black jacket is enlivened by gold tassels and embroidered decoration along with prominent display of the collar and badge of the Order of Saint-Michel, one of the highest honors the king could bestow on a nobleman. Beneath a black cap pinned with a hat badge, his face is carefully delineated. For this enamel, it is likely that Limousin relied on a chalk or ink portrait done by another artist at court. For example, *Odet de Coligny, Cardinal de Châtillon (1515–1571)* (no. 17) closely follows details of a drawing by François Clouet of around 1553 in the Musée Condé at Chantilly (fig. 7) though its bold

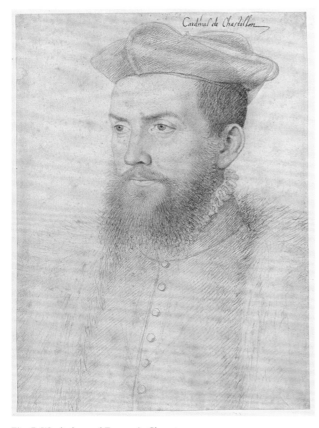

Fig. 7. Workshop of François Clouet, *Odet de Coligny, Cardinal de Châtillon*, ca. 1553. Black and red chalk on paper, 12 ½ × 8 ⅞ in. (31.8 × 22.5 cm). Musée Condé, Chantilly. RMN–Grand Palais / © Art Resource

design with prominent white ermine trim gives it a more sumptuous effect.[31]

Singular among the Frick portraits is Limousin's *Triumph of the Eucharist and the Catholic Faith* (no. 19), which includes living and posthumous portraits of the Guise family.[32] Group portraits are somewhat rare during this epoch in France. A portrait of Odet de Coligny with his two brothers, Gaspard II de Coligny, admiral of France, and François de Coligny, Seigneur d'Andelot, of about 1555 in the Mauritshuis, The Hague, is an exception.[33] What is intriguing about the comparison of these two family portraits is that the de Coligny family members became leaders in the ranks of the Huguenots during the Wars of Religion in the 1560s and 1570s while the Guises were their principal opponents in the Catholic League. The Guises had risen to prominence through the distinguished careers of the first Duke of Guise, Claude de Lorraine, a military commander shown hand on sword hilt at center, strolling with his brother, Jean, Cardinal de Lorraine, the wealthiest prelate in France. Both Claude and Jean died in 1550 and were replaced by the next generation, François, the second Duke of Guise and a chief general of the French armies, and Charles, the most influential cardinal of his day. Appropriately, these still-living descendants are shown in action: François turning the chariot wheels over the heads of Protestants

and Charles orating beneath his emblem, an ivy-covered obelisk. Riding in the chariot pulled by doves is Antoinette, Claude's wife and the family matriarch, who holds aloft a chalice and host, the religious symbol of the Eucharist, belief in which divided Catholics from Protestants.[34] As both a group portrait and allegory of faith at a moment of religious conflict, Limousin's composition is unusual among Limoges enamels.

FUNCTION AND PRESENTATION

As we have seen, enamels served a variety of functions. Many were private altarpieces made for religious devotion in the chapel of a chateau or to be placed on a prie-dieu (kneeling bench for prayer). One can imagine a unique plaque like the *Triumph of the Eucharist* framed by itself as a focal point of a small room. Some portraits were conceived to be set into walls in series, as Catherine de' Medici arranged for her Parisian house.[35] It has been suggested that the oval plate representing Ceres on one side and Minerva on the other (no. 30), signed by Martial Reymond in the late sixteenth century, may have been intended to be set into a door and seen on both sides.[36] The existence of a related enamel at the Herzog Anton Ulrich-Museum in Braunschweig, Germany—probably representing Mars and an unidentified female figure—suggests that the two plaques were part of a coordinated interior scheme. The

use of enamel at this scale emerged during the Renaissance as craftsmen grew more confident in enameling on larger copper surfaces.

Limoges enamels were also used to make services of plates or vessels. Dated 1566, an ensemble of twelve plates representing the activities associated with each month of the year was executed for the president of the Parlement of Paris, Pierre Séguier (1504–1580) (Walters Art Museum, Baltimore, and elsewhere).[37] Pierre Reymond produced a service in 1558 for the Nuremberg merchant Linhard Tucher, who had an office in Lyon.[38] In the late sixteenth to early seventeenth centuries, Jean Pénicaud III made a ewer (no. 39) with scenes of the Trojan War, emblazoned with the arms of Dominique de Vic, Abbot of Bec-Hellouin. While no other enamels with this coat of arms survive, it is likely that this ewer was part of a set.

Such services were intended more for display than for use in serving food and drink. Few of these precious works bear traces of scratches from eating utensils. Instead, numerous citations indicate that these services, as well as individual pieces, were used to ornament credenzas and buffets. Catherine de' Medici had sixty-five enamels in her chateau at Nérac in 1555, probably arranged on pieces of furniture.[39] Anne de Montmorency, the wealthy commander of the French armies, displayed thirty-four enamels, apparently

intermingled with other treasures, on shelves in his Parisian residence.[40]

THE ARTISTS OF LIMOGES

Louis XI (r. 1461–83) issued edicts that allowed the rank of guild master to descend within families. Thus, by royal decree, the craft of enameling was restricted to a few masters in the city of Limoges, and their workshops and families maintained their practices over the course of the late fifteenth through the early seventeenth centuries.[41] Broad trends can therefore be followed for more than a century and a half. In the early period, the focus was mainly on religious subjects based on Franco-Flemish manuscript illuminations or on German prints by Dürer or Schongauer. The compositions depend on strong outlines and defined areas of color. One of the greatest and, through his progeny, most influential, masters of the late Gothic and early Renaissance period is Nardon Pénicaud (ca. 1470–1541). Philippe Verdier, the distinguished Limoges expert, felt that Nardon's monumental figures owed a debt to the stone sculptures of Entombments and Pietàs of central and northwestern France though the compositions also often reflect northern engravings.[42] His single signed work, dated 1503, is in the Musée de Cluny in Paris. Nardon's younger brother, Jean Pénicaud I (ca. 1470–after 1541), probably worked with the older master and continued his practice after the elder artist died. His

work has a higher-keyed palette and tendency to more dynamic poses of the figures drawn from German print sources but shares Nardon's broad enameling style; therefore, the two can be difficult to differentiate. Of this group of early artisans, the Master of the Orléans Triptych (act. late 15th–early 16th century) also creates fairly blocky figures and simplified draperies and has distinctly northern European influences.[43] The figures fill the field densely, and their poses are still and solid. A small number of enamels by this anonymous artist have been grouped around some of his best works in the Walters Art Museum, Baltimore, and in the Musée des Beaux-Arts, Orléans. The Master of the Large Foreheads (act. ca. 1480–1520)—so named by J. J. Marquet de Vasselot, another Limoges specialist—shares certain traits with the artist who created the Orléans triptychs and may have trained in his workshop.[44] The idiosyncratically pronounced foreheads separate him from the former master, whose propensity for narrowed eyes and darkened sockets he shares. An indulgence in decorative pattern—whether gold clouds filling the blue sky, jewels outlining the saints' haloes, or gem-like flowers covering the ground—is notable in this artist's production.

After about 1530, the next generation led the evolution of painted enamel toward a full expression of the values of the Renaissance. Biblical subjects continued but in a wider range, and scenes from antiquity became

increasingly popular, consistent with a new spirit of classicizing forms that swept through all the arts in France. More luxurious vessels began to appear, such as oval platters and ewers. The sober but refined grisaille technique took hold at mid-century, as seen in the style of Jean Pénicaud II (act. ca. 1531–ca. 1549) and followed closely by Jean Pénicaud III (act. ca. 1570–ca. 1610).

Léonard Limousin and Pierre Reymond figure prominently during this period. Limousin (ca. 1505–1575/77) was versatile in his practice of other art forms and, with his connections to the court, helped bring the production of the city to national and international attention.[45] Known to have worked as a painter of ephemeral decorations for a triumphal entry of King Charles IX and Catherine de' Medici in Bordeaux and to have tried his hand at etching, he was one of the first to work on larger-scale enamels for architectural decorations, such as a series of twelve large plaques of the apostles in 1547, after drawings by Francesco Primaticcio, set in the chapel of the chateau at Anet (now in the Musée des Beaux-Arts, Chartres). He is best known, however, for enamel portraits. His large oval plaques of personages such as Anne de Montmorency and François de Lorraine of 1556 and 1557, respectively, show an ambition to rival paintings on panel and canvas. Yet his small enamel portraits with fine stippling are some of the finest works from his hand; fairly sober in palette early in his career, they radiated with increasingly bright colors later.

The sophisticated style of Pierre Reymond (ca. 1513–after 1584) was highly sought after, judging from his considerable production. Many of his enamels were related to services— saltcellars, dishes, ewers—and caskets.[46] He was a master of grisaille but also of elegantly integrated decorative motifs. Colin Nouailher (act. 1539–after 1571) worked mainly in the grisaille technique of Pierre Reymond or Jean Pénicaud II, specializing in caskets often inscribed with mottoes in Limousin dialect, while Pierre Courteys (ca. 1520–before 1591) also followed Reymond's manner, adding more polychromy and placing his figures in active poses. In the wake of these artists, Jean Reymond (d. 1602/3) and Martial Reymond (d. 1599) practiced to the end of the sixteenth century.

Among the most active of the enamelers in the last decades of the century were those who signed their work as IC and IDC, who may have been one and the same, possibly Jean de Court.[47] He may have been the same Jean de Court who succeeded François Clouet as painter to King Charles IX. Sometimes his work features brilliant colors, as in the *Adoration of the Shepherds* (no. 37), but it can also incorporate more subtly shaded images with striking patterns, as in the pillar candlestick (no. 34). Suzanne de Court (act. late 16th–early 17th century)

likely belonged to this family and shares with
Jean de Court a love of strong colors but has
her own engagingly quirky sense of design.

 By the seventeenth century, Limoges
enamels were still being made in the tradition
of earlier masters, but they lacked the flair
and assurance of the great examples of
the mid-sixteenth century. In a repetitive
way, minor masters like Jean Guibert (d. by
1618) continued to adapt earlier designs.
Jean Limousin II (act. ca. 1600–ca. 1650)
produced refined small-scale objects.
While the glorious enamel tradition of the
Renaissance waned in subsequent centuries,
it was revived in the nineteenth century,
especially in Paris, with a highly proficient
technical style, at a moment when many of
the early enamels were restored and when the
collecting of these works began in earnest.[48]
It was in this period that the foundation
was laid for Henry Clay Frick's purchases,
and distinguished museums like The Frick
Collection became repositories of the enamels
that continue to delight visitors today.

Notes

1 Bailey 2006, 81–82.

2 Vignon 2015.

3 On the history of Duveen and Frick, see Vignon forthcoming.

4 Another two enamels were purchased in August 1916 (later given to the Frick by family members) and another four in 1918.

5 Baratte 2000.

6 Baldry 1904; Higgott 2011.

7 Read 1902; V&A 1926.

8 Verdier 1967; Verdier 1995, 328–405.

9 See Maryon 1971.

10 Boehm and Taburet-Delahaye 1996, 49.

11 For an overview of enameling techniques, see Gauthier 1972.

12 On painting technique generally, see Speel 1997.

13 For paillons and their restoration, see Schwahn 2014.

14 For Limoges as a "local specialty," see Zerner 2003, 312–15.

15 Verdier 1977, 86.

16 Ross 1941.

17 Gatouillat 2011, 207–9.

18 Emiliani 1960, pls. 30–32; Verdier 1977, 188–93.

19 Landau and Parshall 1994, 1–6.

20 See Sharratt 2005; Romier (1949, 5) discusses the influence of Lyons printers and booksellers.

21 Verdier (1977, 198) suggests that Jean de Court "pirated" these motifs from Pierre Reymond's enamels.

22 Verdier (1977, 222–25) comments on the treatment of the myth of Orpheus in Renaissance art.

23 For the grotesque motif in the Renaissance, see Dacos 1969.

24 Verdier 1977, 48, n. 2. For the now-missing wings, see Marquet de Vasselot 1921, 284–85, no. 115.

25 On Becket subjects in champlevé enamel, see Boehm and Taburet-Delahaye 1996, 14.

26 See Bautier 1990.

27 Bonnaffé 1874, 155–56, nos. 842, 843, 848.

28 See Jollet 1997.

29 See Baratte 1993.

30 Bonnaffé 1874, 155–56, nos. 842, 843; see Zvereva 2008.

31 Ibid., 143–44, cat. 68.

32 The first article to fully study this plaque was Ritchie 1939. The most recent, and convincing, reading of its identified portraits and its meaning is Grand-Dewyse 2011, 141–206.

33 See Archives Nationales 1972, 128, no. 454, and 119, no. 401.

34 The Guises and their influence on the arts have been the subject of increased study in recent years. See Bellanger 1997 and Wardropper 1991.

35 See Crépin-Leblond 2010.

36 Verdier 1977, 170 and n. 4.

37 Verdier 1967, nos. 142–43, 249–53.

38 For services, see Crépin-Leblond 1995, 105.

39 Havard 1896, 307.

40 Bedos Rezak 1990, 317–18.

41 Verdier 1977, 6.

42 Ibid., 30; Verdier (1967, xvii–xxvi) provides useful summaries of the careers of Limoges enamelers.

43 While Philippe Verdier renamed the artist Master of the Baltimore and Orléans triptychs (Verdier 1977, 18), Sophie Baratte argues that the traditional Master of the Orléans Triptych was more apt as this work was his best known. See a useful discussion in Vincent 2012, 8.

44 Marquet de Vasselot 1921, no. 69, pl. XXV. For the naming of the Master of the Large Foreheads, see Marquet de Vasselot 1921, 137–49.

45 On Léonard Limousin, see Baratte 1993.

46 On Reymond, see Verdier 1967, xxii–iv.

47 Vincent (2012, 15) discusses the artist's name and biography.

48 On nineteenth-century enameling and fakes, see Slitine 2002.

THE
COLLECTION

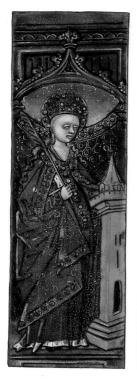
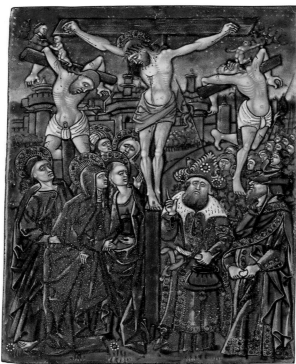
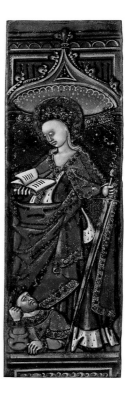

1

Master of the Orléans Triptych
Triptych: The Crucifixion with
St. Barbara and St. Catherine
of Alexandria, ca. 1500
Central plaque: 8 × 6 ⅜ in.
(20.3 × 16.2 cm); wings:
8 ⅛ × 2 ⅝ in. (20.6 × 16.7 cm)
Henry Clay Frick Bequest (1918.4.01)
—

Illuminated manuscripts served as
models for enamelers before prints
were widely circulated and used as
compositional sources. A book of
hours belonging to the wife of the
consul of Limoges by 1510 (now at
the Art Institute of Chicago) was the
origin of this enamel and of other
works by this anonymous master,

named for a well-known triptych
of the Annunciation in the Musée
des Beaux-Arts, Orléans. The ovoid
heads with sunken eyes relate to the
Master of the Large Foreheads, but
this artist has more of a penchant
for pattern, as can be seen in the
many "jewels" decorating haloes
and hems.

2

Workshop of the Master of the
Large Foreheads
Triptych: The Crucifixion with The
Way to Calvary and The Deposition,
ca. 1510
Central plaque: 9 ¼ × 8 ⅛ in.
(23.5 × 20.6 cm); wings:
9 ¼ × 3 ½ in. (23.4 × 8.9 cm)
Henry Clay Frick Bequest (1916.4.05)
—

This master followed the precedents
of established enamelers, modeling
his Christ on one by Nardon Pénicaud
(no. 7) while the Thieves are closer
to those of the Master of the Orléans
Triptych (no. 1). Nonetheless, he created
a luminous work that harmonizes the
three panels through the placement
of the figures in the landscape and the
consistent use of color.

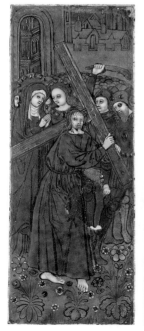
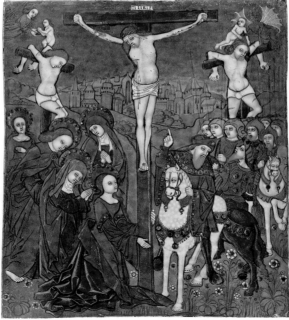
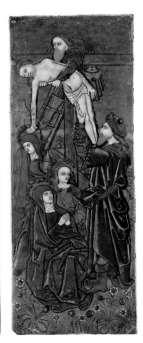

3

Workshop of the Master of
the Large Foreheads
The Adoration of the Magi, ca. 1510
10 ¼ × 9 ⅛ in. (26 × 23.2 cm)
Henry Clay Frick Bequest (1916.4.04)
—

The serious tone of this composition
is lightened by the exaggerated
foreheads that engagingly
distinguish this master's style.
The Master of the Orléans
Triptych provided the basis for
the grouping of figures, as well as
the characterization of faces. This
younger master may well have
trained in the other's workshop,
since he assumes many of the
Master of the Orléans Triptych's
mannerisms without becoming fully
adept at his technique.

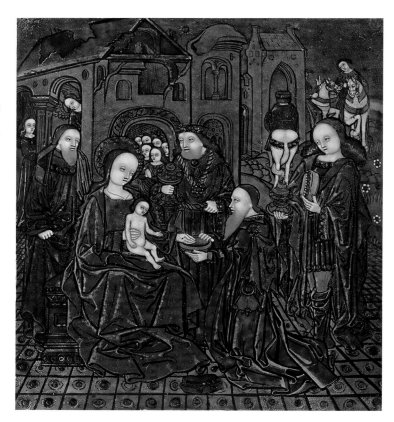

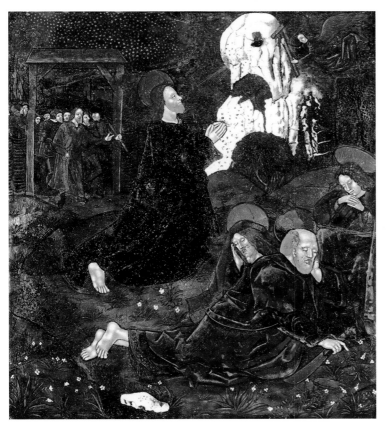

4

Jean Pénicaud I
The Agony in the Garden,
ca. 1520–25
Signed on the rock at lower left:
IP [effaced]
10 ⅞ × 9 ½ in. (27.6 × 24.1 cm)
Henry Clay Frick Bequest (1916.4.06)
—
Sorting out the hands of various
members of the Pénicaud family can
be difficult. Were it not for now-
faded initials on the white rock in
the foreground, the identification
of Jean, the presumed younger
brother of Nardon, would have been
uncertain. One of the first Limoges
enamelers to make extensive use of
German print sources, he borrowed
the basic composition from an
engraving by Martin Schongauer
that shows Christ praying to a flying
angel as the apostles James, Peter,
and John doze in the foreground.
While damage and repairs mar
the surface, the enamel colors
nonetheless complement this night
scene and maintain the focus on
Christ's intensity.

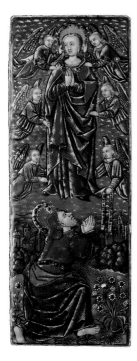
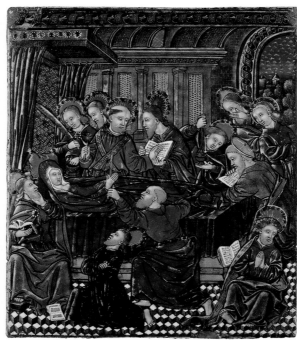
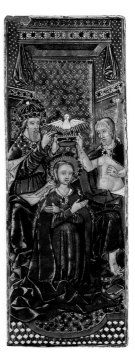

5

Workshop of Nardon Pénicaud
*Triptych: The Death of the
Virgin with The Assumption
and The Coronation,*
ca. 1520–25
Central plaque: 9 ⅛ × 7 ½ in.
(23.2 × 19.1 cm); wings: 9 ⅛ × 3 ¼ in.
(23.2 × 8.3 cm)
Henry Clay Frick Bequest (1916.4.02)
—

The glowing imagery of stained-glass windows was a source of inspiration for some brilliantly hued enamels. A window of about 1510–20 in the second bay of Saint-Pierre-du-Queyroix in Limoges (see fig. 4)—which features a scene of the Death of the Virgin—guided the disposition of the attendants praying and reading holy texts before and behind Mary's bed in this enamel's central plaque. The stained-glass Coronation surmounting this scene is a model for the figure of the kneeling Virgin with God the Father and Christ crowning her. While these scenes find parallels in other plaques, this version of the Assumption, with the incident of St. Thomas receiving the Virgin's sash from an angel, is unique in enamel.

6

Workshop of Nardon Pénicaud
or Jean Pénicaud I
Triptych: The Crucifixion with The
Way to Calvary and The Deposition,
ca. 1520–25
Central plaque: 10 ³⁄₁₆ × 9 ½ in.
(25.9 × 24.1 cm); wings:
10 ½ × 3 ¾ in. (26.7 × 9.5 cm)
Henry Clay Frick Bequest (1918.4.08)
—

The prime version of this Crucifixion
scene is in a triptych in the Walters
Art Museum, Baltimore, securely
attributed to Nardon Pénicaud. His
source was a woodcut in a book of
hours first published in Paris in 1505.
Nardon's work was copied in several
variations within his workshop and
in that of his younger brother, Jean I.

In this version, the enameler
simplifies contours and draperies
and broad facial features. More
idiosyncratic are the white dots at
the knuckles of fingers, the spritely
line he uses for the curling tail of the
horse, and the pattern of bumps on
the horse's hide.

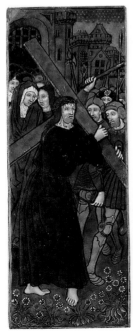
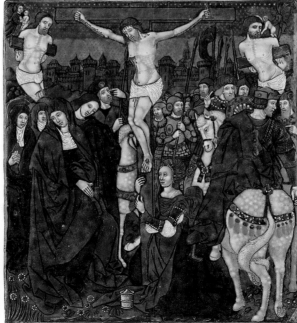
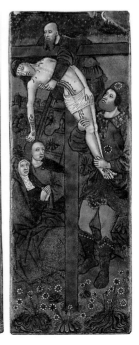

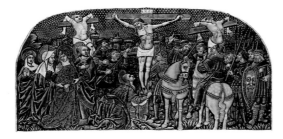
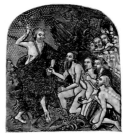
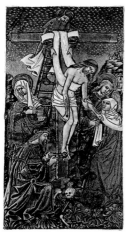
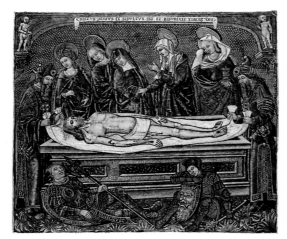
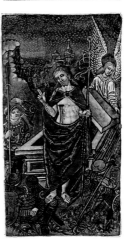

7

Workshop of Nardon Pénicaud
*Double-Tiered Triptych: Scenes
from the Passion of Christ,*
mid-16th century
Upper central plaque: 5 ½ × 11 in.
(14 × 28 cm); upper wings:
5 ¾ × 4 ¾ in. (14.6 × 12 cm);
lower central plaque: 9 ⅞ × 11 ⅜ in.
(25.1 × 28.9 cm); lower wings:
9 ¾ × 5 in. (24.8 × 12.7 cm)
Henry Clay Frick Bequest (1916.4.03)
—

This is one of the most spectacular
enamels in the collection. Stone
sculptures of the Entombment
installed in chapels were important
features of churches in central
France, and the arch above the
central plaque of this triptych
suggests their influence. The
Entombment scene is surmounted
by the Crucifixion. The left wing
shows episodes preceding the
central Entombment—the Way
to Calvary and the Descent from
the Cross—while the right wing
depicts events that follow—
the Harrowing of Hell and the
Resurrection. The composition's
rich detail includes the image
of Christ's visage imprinted on
Veronica's veil at upper left and the
movingly depicted Adam, Eve, and
St. John the Baptist kneeling before
triumphant Christ at upper right.

8

Jean Pénicaud I
*Triptych: Christ Crowned with
Thorns* with *The Kiss of Judas*
and *The Flagellation*, ca. 1525–35
Central plaque: 10 ⅝ × 9 ⅜ in.
(27 × 23.3 cm); wings:
10 ⅝ × 4 ³⁄₁₆ in. (27 × 10.6 cm)
Henry Clay Frick Bequest (1916.4.07)
—
Pénicaud's translation of Martin
Schongauer's engraving of Christ
Crowned with Thorns (see fig. 5)
into an enamel is instructive. The
Gothic quoin vaults in the print
become classical columns and the
plain floor a vibrant geometric tile,
creating an interior that is more up-
to-date yet more compressed than
its model. The German printmaker's
incisive line vividly characterizes all
the participants in the scene while
the French enameler's approach
results in more neutral expressions.
The greatest difference is in the
use of color—which inspirits the
scene but also subsumes it within
the overall pattern—offset by the
extraordinary flesh tones achieved
by manipulation of the white enamel
and delineation of fine lines.

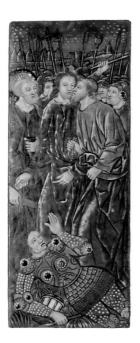
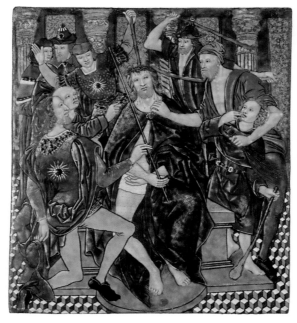
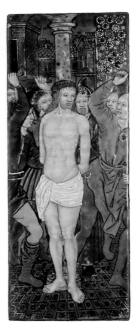

9

Attributed to Jean Pénicaud I
Martyrdom of a Saint, ca. 1525–35
6 ½ × 6 ⅛ in. (16.5 × 15.6 cm)
Henry Clay Frick Bequest (1916.4.10)
—
The identity of the bloodied
saint—possibly James the Less or
Sebastian—is unclear. This scene
of violent martyrdom gives the
enameler scope to devise active
poses and expressive faces. Three
men wielding clubs prepare to
strike at different angles, while
an extravagantly armored soldier
restrains the prostrate man. Graphic
lines precisely detail the hair and
beards of the torturers while more
simply depicted kings and courtiers
stand soberly in the background.

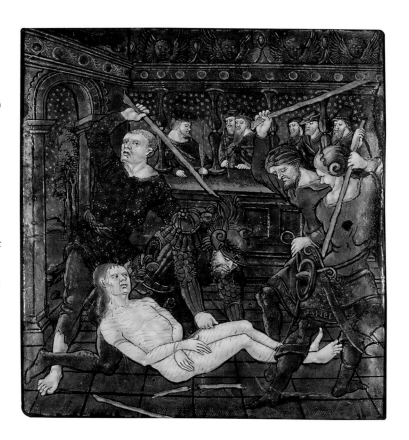

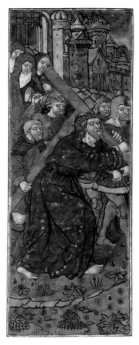
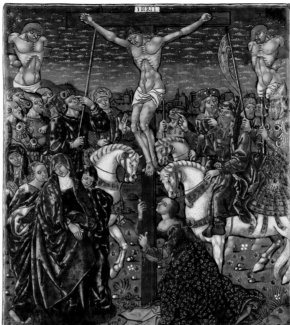
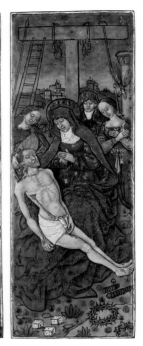

10

Attributed to Jean Pénicaud I or the
Master of the Louis XII Triptych
Triptych: The Crucifixion with
The Way to Calvary and The Pietà,
ca. 1525–35
Central plaque: 10 ³⁄₁₆ × 8 ¾ in.
(25.9 × 22.2 cm); wings:
10 ¼ × 3 ¾ in. (26 × 9.5 cm)
Henry Clay Frick Bequest (1918.4.09)
—

This triptych of the events
surrounding the Crucifixion follows
a standard format and shares print
sources with other versions of the
same scenes. For example, the Way
to Calvary compares closely to
examples by Jean Pénicaud I in the
Musée Jacquemart–André, Paris,
and the Musées Royaux d'Art et

d'Histoire, Brussels. In the central
plaque, the particular penchants
of the enameler emerge: the
sharply defined anatomy of Christ,
the expressive features of the
Thieves, and a crowded composition
enlivened by pattern and extensive
gilding. (Some passages were
enhanced at a later date.)

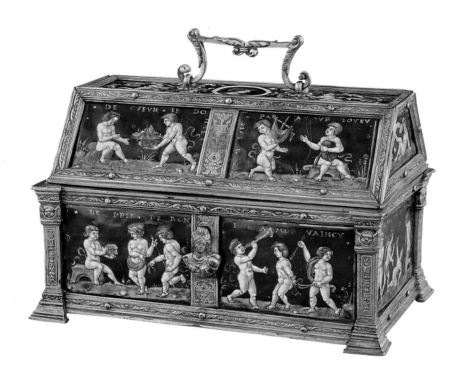

11

Attributed to Colin Nouailher
Casket: Putti and Mottoes of
Courtly Love, ca. 1545
4 ¾ × 7 ¼ × 4 ¾ in. (12 × 18.4 × 12.1 cm)
Henry Clay Frick Bequest (1916.4.14)
—
Twelve plaques depict children
enacting aspects of love specified
by mottoes above them. These
range from a boy bound by a
girl and facing a trumpeter (PAR
AMOUR VAINCU / Defeated by
love) to a seated boy presenting a
casket (much like this enameled
one) to a girl while another lad
holding an arrow watches (LE
PRINS DE BONE FOY / Take it in
good faith). Some two dozen
similar caskets in various
collections testify to the
popularity of these charmingly
decorative works, which may
have served as marriage gifts.
On the lid, the thirteenth plaque
centers on a roundel of Lucretia,
the ancient heroine who chose
suicide over dishonor.

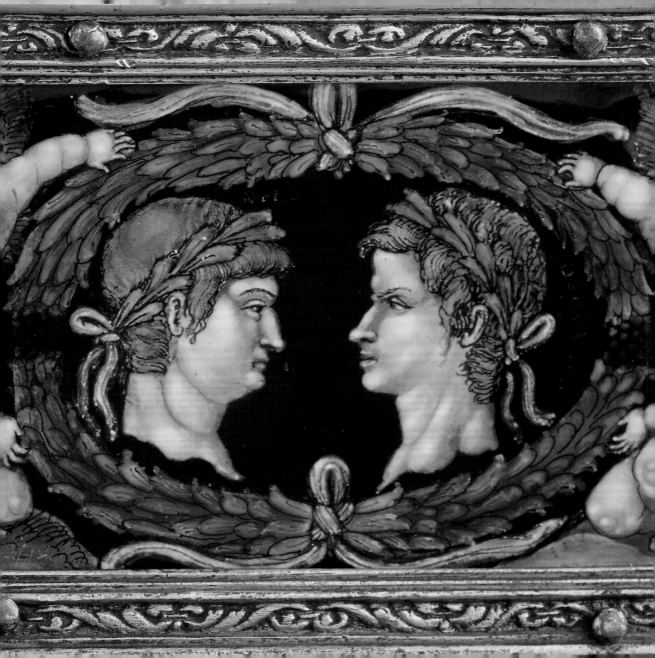

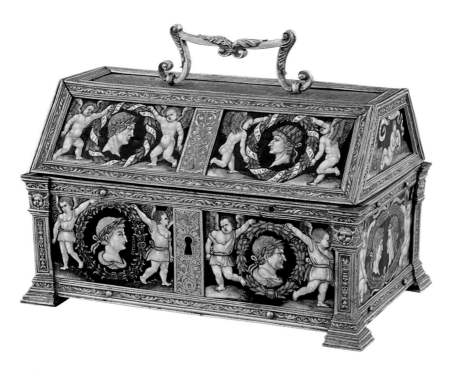

12

Attributed to Colin Nouailher
Casket: Heads of the Caesars
within Wreaths, ca. 1545
4 3/16 × 6 3/4 × 4 7/16 in. (10.7 × 17.2 × 11.3 cm)
Henry Clay Frick Bequest (1916.4.15)
—
In Renaissance France, a fascination
with the Twelve Caesars—reflected
in collections of ancient Roman
sculpture—inspired carved
decorations and terracotta

facade ornaments. Copied
from engravings by the Italian
printmaker Marcantonio Raimondi,
these enameled portraits of stern
emperors are circled by laurel
wreaths held by variously posed
putti. Eight plaques center on a
single image of an emperor, and
double portraits occupy either end.
Two scenes of a putto leaning on a
skull beneath the motto MEMENTO.

MORI.DICO (Remember that you
must die, I say) remind us that all
men, however famous, are mortal.
The gold letters identifying each
Caesar have mostly faded except
on three identical images of
VICELLIO (Vitelius), which replaced
the originals, probably during a
nineteenth-century restoration.

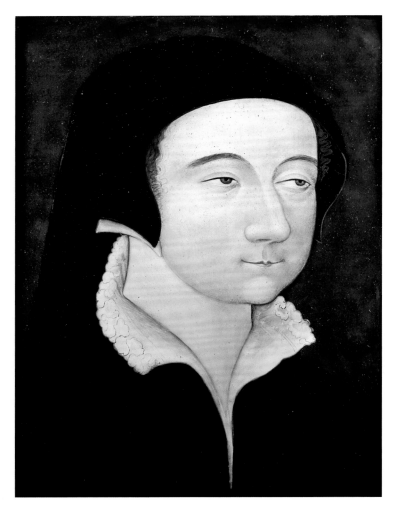

13

Follower of Léonard Limousin
(or Limosin) (?)
Louise de Pisseleu, Madame de
Jarnac, late 16th century or later
Plaque: 9 ⅜ × 7 1/16 in. (23.8 × 18 cm)
Henry Clay Frick Bequest (1916.4.21)
—
This portrait and that of the
sitter's husband, the Baron de
Jarnac (no. 14), were inventoried
in 1762 as framed together in the
Château de Jarnac. Although it is
of the same dimensions as the
other and faces it as a pendant,
its lesser quality—the features
are simplified and flat—suggests
that it is not by the same artist.
Assuming that the provenance is
accurate, this enamel may have
been commissioned to match the
other at a later date.

14

Léonard Limousin (or Limosin)
Guy Chabot, Baron de Jarnac,
1540–45
Plaque: 9 ⅜ × 7 ¹⁄₁₆ in. (23.8 × 18 cm)
Henry Clay Frick Bequest (1916.4.20)
—

A prolific enamel portraitist,
Limousin was famous for small
plaques but also worked in larger
formats, such as this. Even at
this scale, his exacting manner
of stippling can be seen along the
nose and right side of the face, as
well as in the careful lines of white,
brown, and black for the beard.
The embroidered black jacket and
matching cap with gold tassels and
hat badge would date the portrait
to the 1540s, the decade when
Chabot (d. 1584) married Louise de
Pisseleu and was named seneschal
of Périgord.

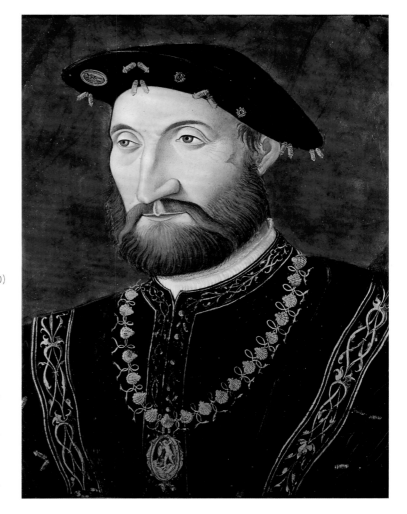

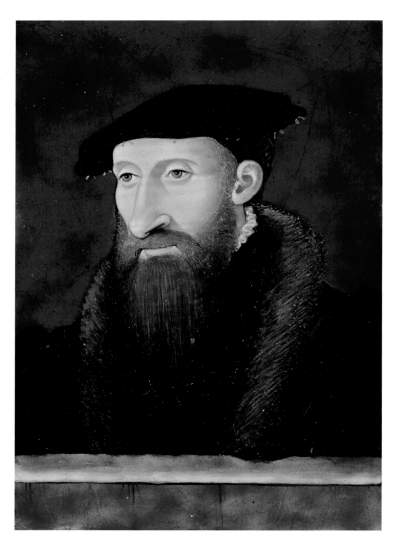

15

Léonard Limousin (or Limosin)
Portrait of a Bearded Man
(Guillaume Farel?), 1546
Signed and dated in gold (faded)
at lower right: LL.1546
7 9/16 × 5 5/8 in. (19.2 × 14.3 cm)
Henry Clay Frick Bequest (1916.4.17)
—

This sensitive portrait was deemed
by the French Limoges expert
Philippe Verdier to be of Guillaume
Farel (1489–1565), a leader of the
Protestant Reform who fled to
Switzerland in 1526. Identifying
subjects through comparison with
other portraits can be problematic.
In the case of Farel, no image of
him exists from the 1540s, only
ones created after his death in
1580, making it difficult to confirm
his identity here. As issues of faith
became increasingly contentious
at mid-century, Limousin seems to
have been careful about crossing
religious lines, only making portraits
of noted Protestants John Calvin and
Théodore de Bèze.

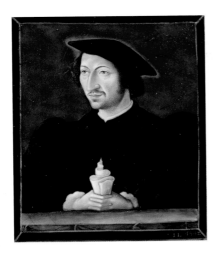

16

Léonard Limousin (or Limosin)
Portrait of a Man, 1542
Signed and dated in gold: LL.1542
5 × 4 ¼ in. (12.7 × 10.8 cm)
Henry Clay Frick Bequest (1916.4.16)
—

As in many of Limousin's portraits,
the sitter is posed behind a parapet or
table before a solid blue background.
Dressed in black with a black cap,
he is shown with a meticulously
rendered beard. Limousin seldom
includes hands in his portraits,
perhaps because they can be
distracting, as are those here, with
the sitter's entwined fingers clasping
an oddly folded piece of paper.

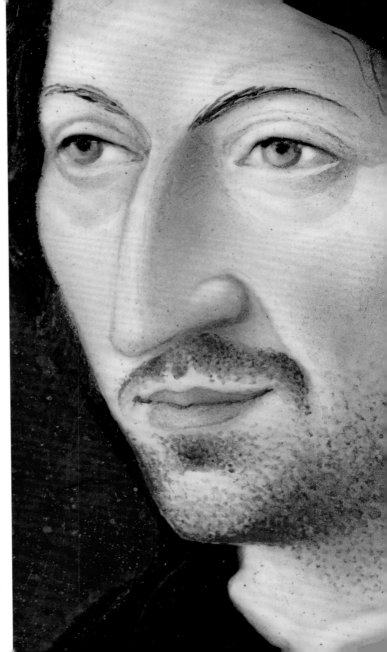

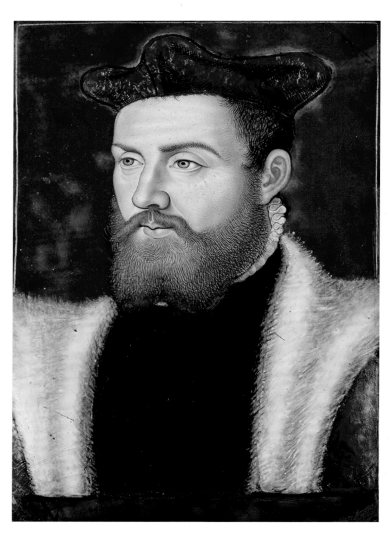

17

Léonard Limousin (or Limosin)
Odet de Coligny, Cardinal de Châtillon (1515–1571), ca. 1555
7 ⁹⁄₁₆ × 5 ¼ in. (19 × 13.4 cm)
Henry Clay Frick Bequest (1916.4.19)
—

The identity of Odet de Coligny is ascertained by the close relationship of this image to a number of contemporary portraits, especially a drawing by François Clouet at Chantilly (see fig. 7) that may have been its direct model. A member of a family that later led Protestant forces in the Wars of Religion, de Coligny was excommunicated in 1563 and fought in the Battle of Saint-Denis in 1567.

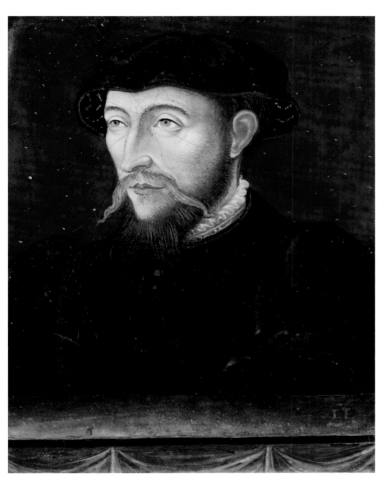

18

Léonard Limousin (or Limosin)
Portrait of a Man (Antoine
de Bourbon?), ca. 1560
Signed in gold at lower right: LL
5 ⅛ × 4 ¼ in. (13 × 10.8 cm)
Henry Clay Frick Bequest (1916.4.18)
—

Traditionally, this portrait has
been thought to represent Antoine
de Bourbon, who became King of
Navarre in 1555 and fathered Henry
IV, King of France. It compares
reasonably, though not conclusively,
with depictions of the man dating
from this epoch. Initially close to
many Protestants, Bourbon abjured
that faith in 1557 and died in battle
against them in 1562.

19

Léonard Limousin (or Limosin)
The Triumph of the Eucharist
and the Catholic Faith, 1561–62
Signed in black on base of obelisk:
LEONARD.L.
7 ¾ × 10 in. (19.7 × 25.4 cm)
Henry Clay Frick Bequest (1916.4.22)
—

A rare enameled group portrait, this plaque represents living and deceased members of the Guise family in an allegory of the Catholic Faith. From the first generation, Claude, Duke of Lorraine, and his brother Jean, Cardinal de Lorraine, both dead in 1550, stroll at center. François, second Duke of Guise and like his father famed for battles against heretics, pushes the chariot wheel over the bodies of Protestants. His brother Charles, identified by his emblem of an ivy-covered obelisk with the motto TE STANTE VIREBO (With you standing, I shall flourish), holds a text that may refer to his address at the Colloque de Poissy, in which he proposed moderation in the current religious conflict. Seated in the chariot is the family matriarch, Antoinette de Bourbon, holding a chalice and host, symbols of transubstantiation—the miracle by which the bread and wine of the Eucharist become the actual body and blood of Christ—a central tenet of Catholicism.

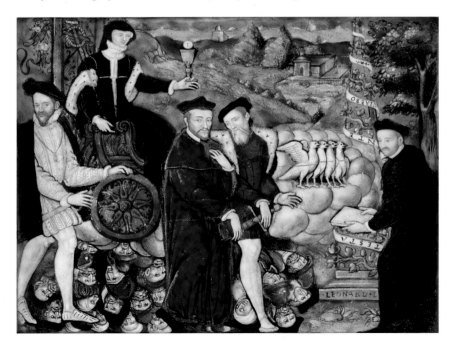

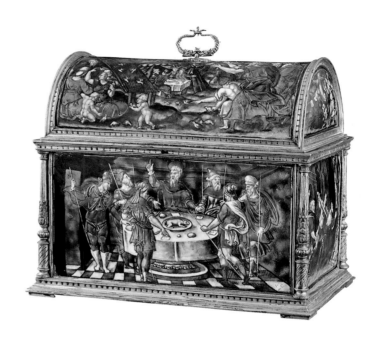

20

Pierre Courteys
Casket: Old Testament Subjects,
mid-16th century
Signed in gold on both back panels
and on front lower panel: .P.C.
8 ⁵⁄₁₆ × 9 ¹³⁄₁₆ × 6 ¼ in. (21.1 × 24.9 × 16 cm)
Henry Clay Frick Bequest (1916.4.33)
—

Pierre Courteys's dark palette and
stern figures set a sober tone for
these eight Old Testament scenes.
The night sky separates the Falling
of Quails in the Desert from the
Gathering of Manna, seen on the
front and back of the curved lid.
Themes concerning Moses join
these episodes to the main scenes
at front and back: the Feast of the
Passover in Egypt and Shaphan
reading to King Josiah from the
Book of the Law of the Lord given
by Moses. Various biblical episodes
decorate the two ends.

21

Pierre Courteys
Casket: Scenes from the Story
of Joseph, late 16th century
Signed in gold on the lid near
the handle: P. COURTEYS
9 ³⁄₈ × 10 ⁵⁄₈ × 6 ³⁄₄ in. (23.8 × 27 × 17.1 cm)
Henry Clay Frick Bequest (1916.4.32)

—

The dramatic story of Joseph's
life inspired the unified series
of plaques on this casket. These
begin with the youth fleeing the
embrace of Potiphar's wife on an
end plaque, move to his interpreting
the meaning of the seven fat and
lean cattle in Pharaoh's dream on
one side of the lid, and conclude with
his brothers supplicating before
the enthroned king on the front.
Drawing upon Bernard Salomon's
woodcut illustrations for Claude
Paradin's *Quadrins historiques de la
Bible* (see fig. 6), Courteys enameled
these straightforward compositions
in translucent colors directly on
copper or clear enamel, creating a
dark palette. Unusually, the plaques
are contained within a painted and
gilded wood frame with enameled
columns on the four corners, instead
of the typical metal casket frame.

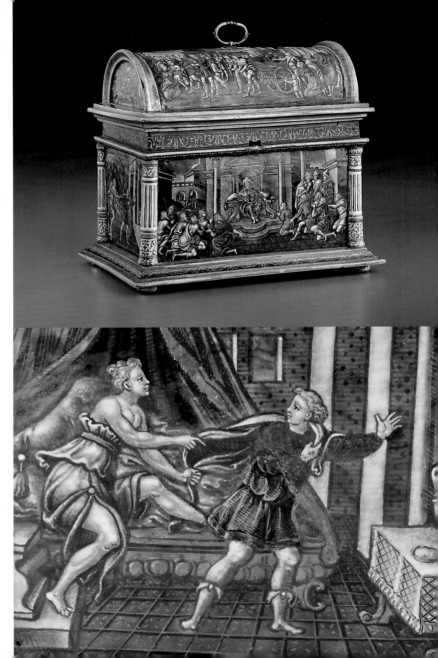

22

Workshop of Pierre Reymond
The Seven Sorrows of the Virgin,
1533
Dated in gold above lower left
medallion: 1533
7 ⅛ × 5 ¾ in. (18.1 × 14.6 cm)
Henry Clay Frick Bequest (1916.4.11)
—
Beginning with the Circumcision
at upper left and moving clockwise
to the Entombment, the Seven
Sorrows of the Virgin are depicted in
roundels, each with a silvered sword
pointing at her heart. The belief
that the Virgin suffered through
compassion as Christ did in his
Passion inspired the formation of
confraternities in northern Europe
at the end of the fifteenth century
and later. Brilliantly executed, with
a bright green background, this
small plaque recently reattributed
to the workshop of Pierre Reymond
was meant for personal veneration.
Its date of 1533 makes it one of
Reymond's earliest works.

23

Attributed to the workshop
of Pierre Reymond
Casket: Old Testament Subjects,
mid-16th century with later additions
4 ½ × 6 ½ × 4 ½ in. (11.4 × 16.5 × 11.4 cm)
Henry Clay Frick Bequest (1916.4.24)
—
These fourteen scenes from the Old
Testament are similarly enameled

with figures in tinted grisaille
standing on green grass before
a dark blue sky, each inscribed
with a description in gold letters.
While some of the subjects are
related—Lot and his daughters,
Lot fleeing the burning city; Daniel
in the lion's den, Daniel destroying
the dragon—there is no apparent

overall program for the casket.
Stylistically, it is clear that more
than one hand was involved, and
the four scenes on the back side
(below left) were executed by a
different artist from those on the
front. The plaques may have been
reconstituted on this casket at a
later date.

24

Workshop of Pierre Reymond
Two Plaques: The Agony in the Garden; Christ Crowned with Thorns, mid- to late 16th century
Plaques: 8 × 6 ¼ in. (20.3 × 15.9 cm)
Roundels: diam. 2 ¹⁄₁₆ in. (5.2 cm)
Gift of Dr. and Mrs. Henry Clay Frick II, 2005 (2005.4.01–02)
—

Originally, these two scenes of Christ's Passion may have been part of a larger series, but they were framed in the nineteenth century and surrounded by unrelated roundels depicting biblical subjects. A grisaille enamel of Christ in the Garden by Pierre Reymond (The State Hermitage Museum, St. Petersburg) served as the model for the multicolored works here. Though technical analysis confirms that the batch of enamel is exactly the same in *The Agony in the Garden* and *Christ Crowned with Thorns*, the latter plaque's finer draftsmanship and enamel application suggest that two different hands in the same workshop were responsible.

25

Workshop of Pierre Reymond
Ewer Stand: Moses Striking the
Rock, late 16th century
Signed twice in gold on back
of rim: P.R.
H. 1 ½ in. (3.8 cm), diam. 18 in. (45.7 cm)
Henry Clay Frick Bequest (1916.4.25)

—

The densely packed figures circling
the stand recall the tradition of
brass- or silver-work. Although this
is signed P.R. on the back and reflects
the return to bright colors seen in the
master's late work, the relative lack
of vitality in the enameling signals
the hand of an assistant in Pierre
Reymond's workshop.

26

Workshop of Pierre or Jean Reymond
Ewer: The Gathering of Manna;
The Destruction of Pharaoh's Host,
late 16th century
13 × 6 × 4 in. (33 × 15.2 × 10.2 cm)
Henry Clay Frick Bequest (1916.4.26)
—

Two stories concerning Moses from
the Book of Exodus wrap around the
body of this ewer. Above, the biblical
leader commands manna to feed
his people, and the Israelites gather
it as the scene continues around
the sides. Beneath, the sea engulfs
Pharaoh's army as it pursues Moses's
followers, who have safely arrived
on land. A spirited design of falling
manna and roiling waves enlivens
the compositions, and engaging
details, such as the heads of soldiers
poking above the water, can be seen
as the object is rotated. Bread and
water were appropriate subjects for a
pitcher even though this object was
intended for display only.

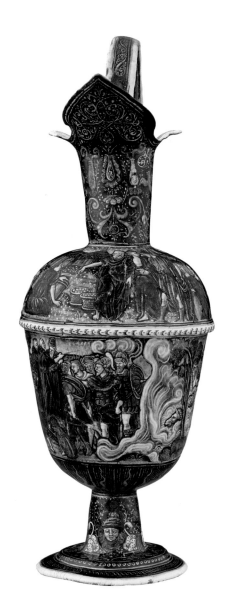

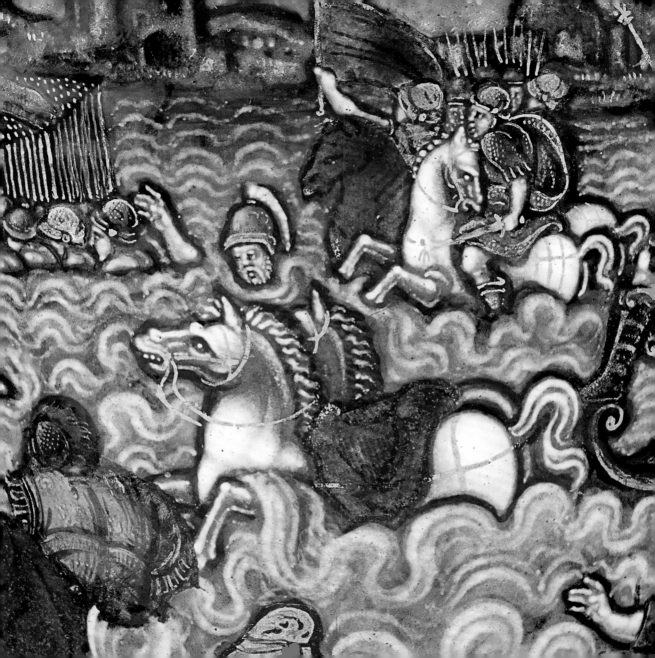

27

Attributed to the Workshop
of Pierre Reymond
Saltcellar: Amorini and Satyrs,
mid–16th century
H. 5 ⁹⁄₁₆ in. (14.1 cm), diam. 3 ½ in. (8.9 cm)
Henry Clay Frick Bequest (1916.4.27)
—

Amusing decorative motifs cover
this saltcellar, which is similar in
shape to one by Master IC in the Frick
(no. 33). Winged children play around
the base, and roundels of classicizing
figures circle the central knop while
more winged figures alternate
with squatting satyrs on the upper
section. A beautifully rendered bust
of a man in a Phrygian cap (headgear
associated with the region of Turkey
in ancient times) decorates the
receptacle (see detail).

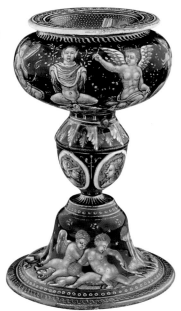

28

Attributed to Jean Reymond
The Adoration of the Magi,
late 16th century
11 ⅞ × 9 ½ in. (30.2 × 24.1 cm)
Henry Clay Frick Bequest (1916.4.28)
—

One of the three kings points to the star of Bethlehem, unseen outside the doorway, which has led them to the Holy Family. Despite old repairs, the royal robes are in rich colors with brilliant blues. This coloration, the accomplished modeling in enamel of the male faces, and the detailed architectural setting link this plaque to the depiction of the Last Supper on an oval dish in the Frick (no. 29). While the plaque is unsigned, the dish is signed I.R. and attributed to Jean Reymond. On this basis, the present plaque is also attributed to Jean Reymond.

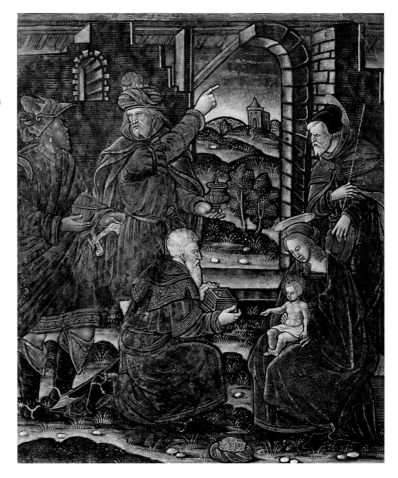

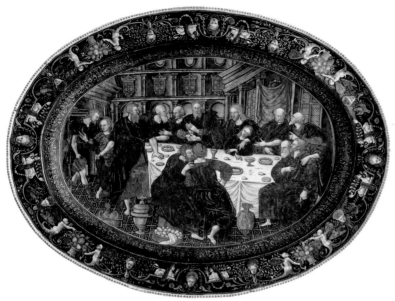

29

Jean Reymond
Oval Dish: The Last Supper; Jupiter,
late 16th century
Signed in gold on back of rim: .I.R.
20 ⅜ × 16 × 2 in. (51.8 × 40.6 × 5.1 cm)
Henry Clay Frick Bequest (1916.4.31)

—

The visual source for this Last
Supper, the rendering of which
is stiff and lacks drama, remains
untraced while that of the reverse
is known to be from engravings by
Étienne Delaune. The reverse, which
shows Jupiter standing on his eagle
in a fanciful grotesque setting, is far
more successful. Christian themes
often coexisted with motifs drawn
from antiquity in Renaissance art.
In the decorative arts, it is unusual
for so much attention to be devoted
to the underside of a vessel, yet
this was often the case for Limoges
enamels. A related oval dish—
featuring Fame on the reverse in an
elaborate grotesque similarly drawn
from engravings by Delaune—is
attributed to Jean Reymond's son
Martial (no. 31).

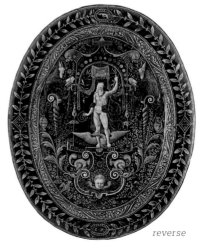

reverse

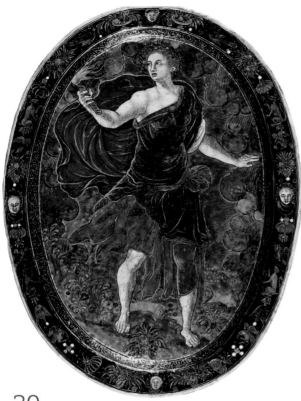

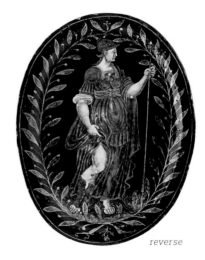

reverse

30

Martial Reymond
Oval Plate: Ceres Holding a Torch;
Minerva, late 16th century
Signed in gold letters below left
foot of Ceres: MR
14 ½ × 10 9/16 in. (35.9 × 26.8 cm)
Henry Clay Frick Bequest (1916.4.30)
—
This bold plate depicts Ceres
searching by torchlight for her
abducted daughter Proserpina at
the Gates of Hell. As in the *Apollo
and the Muses* dish (no. 31), the
artist combines hatched lines
with gray and white to create
flesh tones along with a palette of
dark greens, blues, and browns.
On the reverse is an equally large
image of the goddess Minerva,
suggesting that the oval might
have been set into a door to be
visible from both sides.

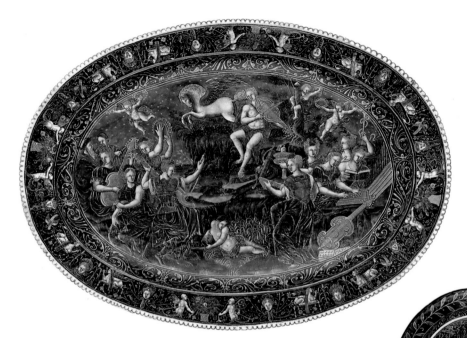

31

Martial Reymond
Oval Dish: Apollo and the Muses;
Fame, late 16th century
Signed in gold letters below
nymph on obverse: MR
21 ⁷⁄₁₆ × 16 × 2 in. (54.4 × 40.6 × 5.1 cm)
Henry Clay Frick Bequest (1916.4.29)
—

Apollo and the Muses was a
popular subject in France,
notably as a principal fresco of
the ballroom at Fontainebleau
in 1552–56. The version in this
enamel traces back to Raphael's
famed composition in the Stanza
della Segnatura in the Vatican
through an engraving by Giorgio
Ghisi. Reymond's style is notable
for the gray flesh tones, lavish
use of gilding, and translucent
enamels over silver paillons.

reverse

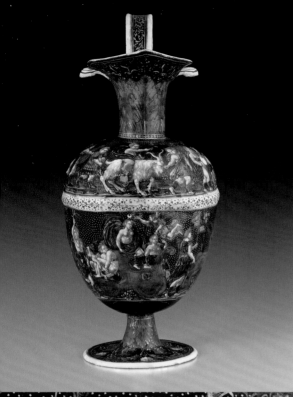

32

Master IC
Ewer: Triumph of Bacchus; Triumph
of Diana, late 16th century
Signed in black inside lip
beneath handle: .I.C.
11 ⅛ × 6 ¾ × 5 in. (28.3 × 17.1 × 12.7 cm)
Henry Clay Frick Bequest (1916.4.35)
—

A parade makes a satisfying
decoration for a ewer, which
could be turned by the viewer to
follow the sequence of figures and
animals. Ancient Roman sarcophagi
were the original sources of these
superimposed images of putti
leading a sacrificial ram and of
the chariot-riding goddess Diana
attended by horn players, stags, and
bound prisoners. Master IC borrowed
his compositions from engravings
by Jacques Androuet du Cerceau
designed about 1546 precisely
for decorative artists to apply to
vessels like this. Centering Diana
and the sacrificial ram below the
spout, the enameler adeptly circles
the bulbous ewer with a cadence of
naked figures and brilliant colors.

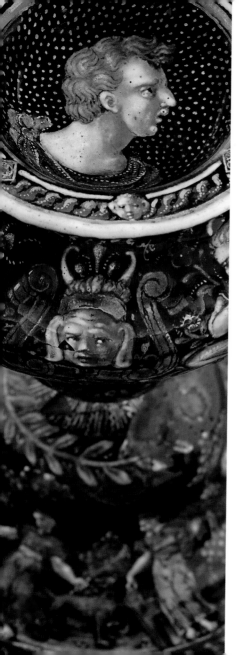

33

Master IC
Saltcellar in Baluster Form:
Bacchic Procession; Putti and
Satyrs, late 16th century
Signed in gold inside foot: .I.C.
H. 15 ⅛ in. (13 cm)
Henry Clay Frick Bequest
(1916.4.37)

—

Master IC faced the challenge
of fitting a procession around
the concave base of this
saltcellar rather than on the
convex body of a ewer (no. 32).
The artist takes advantage of
the complex baluster shapes
by adapting decoration to their
sides: women holding garlands
on the knop and seated male
figures flanking comic heads
on the bowl. The bust of an
ancient Roman fits inside the
bowl (see detail), where it
would have been discovered
beneath the salt had it actually
been used at a banquet.

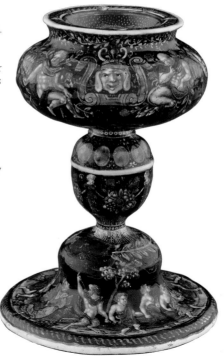

34

Master IC
Candlestick: Olympian Deities
and the Labors of Hercules,
late 16th century
Signed in gold inside foot: .I.C.
H. 11 ¾ in. (29.8 cm), diam.
8 ½ in. (20.6 cm)
Henry Clay Frick Bequest
(1918.4.36)
—

Striking arabesque ornament
draws attention to the shaft of
this candlestick, called a pillar
candlestick or "à la romaine"
(in the Roman manner). The
enameler's art, however, was
mainly devoted to the twelve
raised bosses circling the base.
Here, gods and goddesses—
Diana, Juno, Jupiter, Mars,
Minerva, and Venus—alternate
with the Labors of Hercules.
There was once almost certainly
a second candlestick, completing
the sequence of gods and labors;
related pairs are known in the
British Museum and elsewhere.

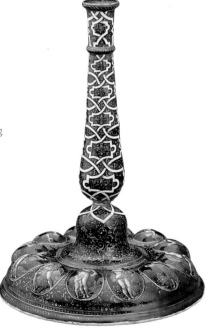

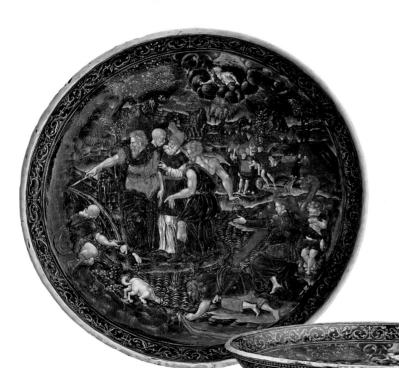

35

Master IC
Cup: Moses Striking the Rock,
late 16th century
Signed in blue on underside
of bowl: .I.C.
H. 4 ⅝ in. (10.9 cm), diam. 10 in. (25.4 cm)
Henry Clay Frick Bequest (1916.4.38)
—

The enameler adapted a rectangular
woodcut of *Moses Striking the
Rock* by Bernard Salomon (see fig.
6) to the circular format, offsetting
the central group with foreground
figures around the perimeter and
another group in the distance. Dark
blues, greens, and purplish reds
against turquoise and flesh tones
make a distinctive palette that ties
this work closely to a cup (or tazza)
of *Lot and His Daughters* (no. 36). On
the underside of the shallow cup,
curiously imagined heads alternate
with caryatids in a similar disposition
to the other work by Master IC.

36

Master IC
Cup: *Lot and His Daughters*,
late 16th century
Signed in black on the underside
of the bowl: .I.C.
H. 4 ⅜ in. (11.1 cm), diam. 9 ⅞ in. (25.1 cm)
Henry Clay Frick Bequest (1916.4.39)
—

Judicious application of gold enriches the surface of this splendid enamel painting, intensifying the flames from the burning city of Sodom and sprinkled as foliage down the rock cliff and across the grass. Regular patterns of waves and trees further animate the surface. The Old Testament scene of Lot seduced by his daughters (from Genesis 19, as noted by the inscription G XIX) occupies the foreground. The sumptuously colored robes contrast with the only figure fully in grisaille, Lot's wife turned to salt, who appears like a ghostly statue.

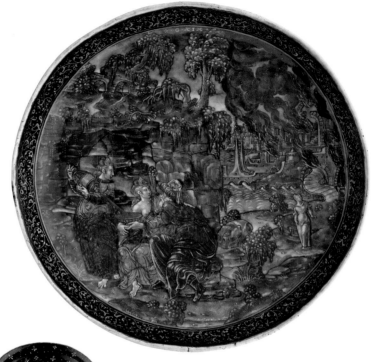

underside

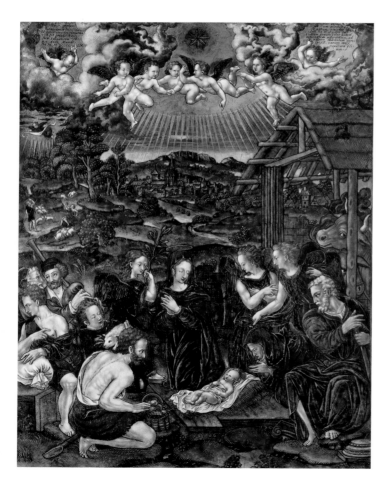

37

Master IDC
Adoration of the Shepherds,
late 16th or early 17th century
Signed in gold on the stone
beneath Christ Child: I.D.C.
17 ½ × 13 ⁷⁄₁₆ in. (44.5 × 34.1 cm)
Henry Clay Frick Bequest (1916.4.34)
—
The enameler has meticulously
copied engravings by Giorgio Ghisi
and Cornelis Cort after a famous
painting by Agnolo Bronzino in
Florence dated 1530–40 (now in the
Museum of Fine Arts, Budapest). As
a result, the figures are portrayed
more stiffly than was this master's
custom. Yet, the careful rendering
of marmoreal flesh, rich colors,
brilliant radiance from the star of
Bethlehem, and the large scale of
the enameled copper plate make
this an exceptional and luxurious
devotional image.

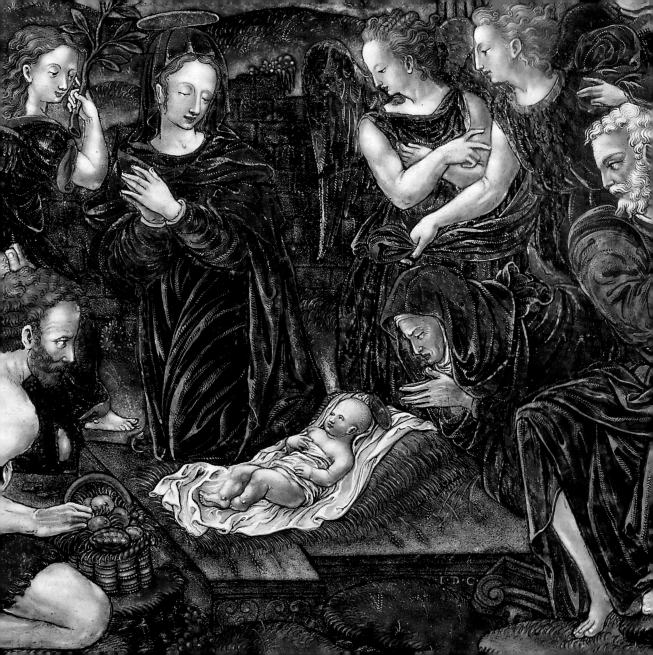

38

Suzanne de Court
Pair of Saltcellars: Scenes from
the Story of Orpheus, late 16th
or early 17th century
Signed in gold below Orpheus
on 1916.4.43 and below Apollo
on 1916.4.44: .S.C.
Each, h. 3 ½ in. (8.9 cm),
diam. 3 ⁹⁄₁₆ in. (9 cm)
Henry Clay Frick Bequest
(1916.4.43–44)
—

Suzanne de Court (or just Court)
signed her name under the principal
protagonist of each salt: Orpheus
calmly playing his lyre as the frenzied
Cicones approach to attack him (see
detail); and Apollo slaying the dragon
that prepares to swallow Orpheus's
severed head. Signs of the artist's
pleasing manner abound: her favorite
colors of royal blue, emerald green,
mauve, and turquoise glow over silver
paillons; gilded patterns are scattered
over a black background; and white
flesh tones are highlighted with
pink. Her spritely touch and sense
of whimsy animate every scene. A
helmeted man matches a crowned
woman in the circular receptacles
topping the salts.

39

Jean Pénicaud III
Ewer: The Trojan Horse;
A Cavalry Combat, late
16th–early 17th century
11 ¼ × 5 ⅜ × 4 ¼ in. (28.6 × 13.7 × 10.8 cm)
Henry Clay Frick Bequest (1916.4.13)
—

Jean Pénicaud III continued the
stylistic traditions of his family's
dynasty into the seventeenth
century. Creating figures in grisaille
toned with a pale flesh hue, he
depicts the Trojan War by drawing
upon sources from two printmakers:
the French etcher Jean Mignon for
the episode of the wooden horse
and the Italian engraver Agostino
Veneziano for the combat of
horsemen. The coat of arms held
by two standing putti is that of
Dominique de Vic, who was Abbot of
Bec-Hellouin when this enamel was
made. Such heraldic devices usually
mark coordinated services, but no
other matching enamels are known.

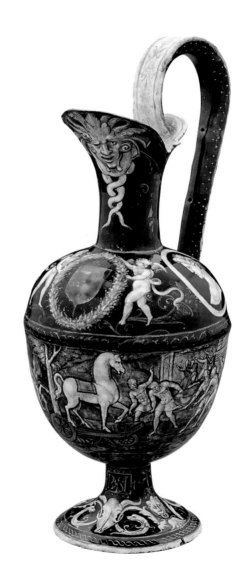

40

Jean Guibert
Pair of Saltcellars: The Story of Minos and Scylla; Allegorical Figures, early 17th century
Signed in gold inside receptacle of each saltcellar: I.G.
Each, h. 4 ⅜ in. (11.1 cm), diam. 6 in. (15.1 cm)
Henry Clay Frick Bequest (1916.4.40–41)
—

Taken from Ovid's *Metamorphoses*, the story tells of Scylla, daughter of King Nisus of Megara, who falls in love with her father's enemy, King Minos of Crete. In one receptacle, Minos rides before Scylla's tower; in the other, she gives him magical locks of her father's hair, which enable him to destroy Megara.

Allegorical figures of Virtues and the Liberal Arts on the sides allude to the tale's moral lessons. Rarely depicted, this myth appears in other enamels of this master, who worked in a somewhat precious manner on small, jewel-like objects.

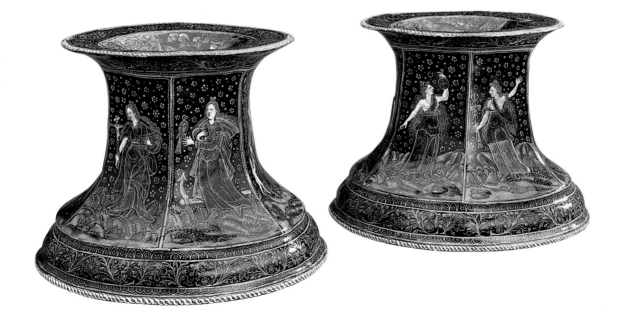

41

Jean Limousin (or Limosin) II
Saltcellar: Olympian Deities,
early 17th century
H. 3 ¾ in (9.5 cm)
Henry Clay Frick Bequest (1916.4.23)
—

Six gods and goddesses—Apollo,
Venus, Diana, Eros, Mars, and
Jupiter—ornament the sides of
this hexagonal salt. It likely had
a companion saltcellar (now lost)
that was enameled with other
gods or allegorical figures, such
as the Liberal Arts. Jean Limousin
II continued the decorative ideas
of his father, Jean I, well into the
seventeenth century.

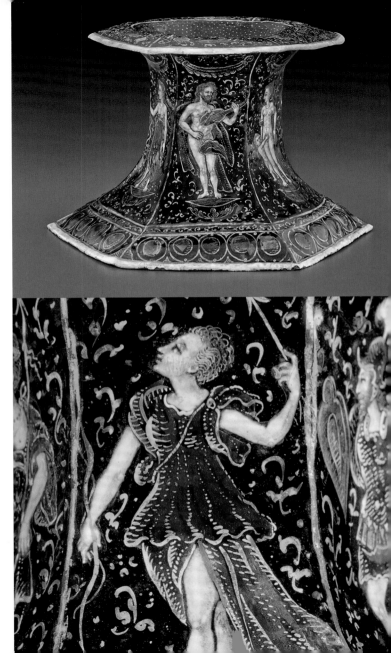

42

Attributed to Jean Limousin (or Limosin)
Ninus, King of Nineveh,
early 17th century or later
8 ³⁄₁₆ × 5 ⅝ in. (20.8 × 14.3 cm)
Henry Clay Frick Bequest (1916.4.42)
—

This concave oval plaque represents
Ninus, the legendary founder of
Nineveh and King of Assyria. The
conquerors of the four great empires
of the ancient world—Ninus, Cyrus,
Alexander, and Julius Caesar—were
popular in the Renaissance, and
illustrations of them based on designs
by Marten de Vos (1532–1603), such
as this example, circulated through
engravings. Although the mottled
pink and gray flesh tones defined by
hatch marks are very similar to those
on the salt by Jean Limousin II (no.
41), the plaque's unusual opaque blue
counter-enamel raises doubts about
its dating and authorship.

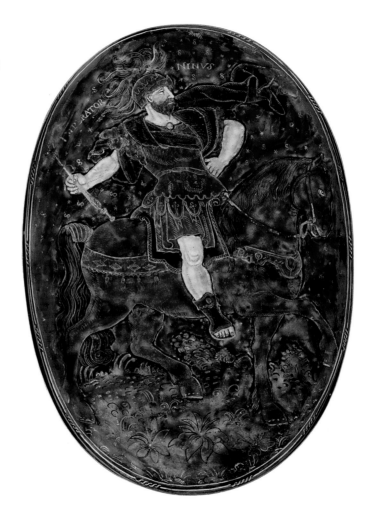

43

In the style of Jean Pénicaud II
Triptych: The Lineage of St. Anne,
19th century (?)
Central plaque: 11 ¾ × 7 ½ in.
(29.9 × 19.1 cm); wings 11 ¾ × 3 ⅛ in.
(29.9 × 8 cm)
Henry Clay Frick Bequest (1916.4.12)
—
The central group of the Virgin and
Child with St. Anne is similar to a
plaque by Jean Pénicaud II in the
Walters Art Museum, Baltimore; both
depend on an engraving by Marco
Dente. Some of its colors, such as the
green-yellow curtains and copper-
red gowns, are unusual for enamels
of this period. The markedly fine
preservation of the lettering on the
banderoles and the exaggerated
features of some figures suggest
that this is a more recent work
copying the manner of a sixteenth-
century artist. The high technical
mastery of many nineteenth-
century enamelers allowed them to
execute not only original work and
homages to the Renaissance but also
deliberate forgeries.

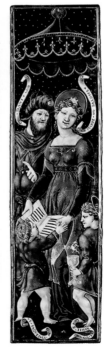

GLOSSARY *by Julia Day*

The following terms are defined as they relate to enameling practices in Europe, and particularly France, during the Renaissance.

COUNTER-ENAMEL

The enamel layer on the back of the metal plate or interior of an object. This layer minimizes the distortion of the metal during the heating and cooling cycles when firing and prevents the enamel on the front from cracking and flaking off. A counter-enamel is particularly necessary for Limoges enamels, due to their shape and size, as well as the multiple firings. Because the vitreous material is on all sides of the Limoges enamel, they must be supported by metal trivets, which provide minimal contact during firing.

ENAMEL

A glass layer applied as a fine powder and fused to a metal substrate using heat. The term is also used to refer to an object decorated with enamel. The glass used by French enamelers during the Renaissance was likely composed of sand and ash from the burning of plants and trees. These ingredients were melted together in a kiln and, upon cooling, formed an amorphous crystalline solid. Enamelers of the period would have ground lumps of the glass by hand using a mortar and pestle. The glass powder would then be washed in water repeatedly before it was applied to the metal plate as a wet paste. After the paste had completely dried, the object would be placed in

a **kiln** and fired. This process was repeated several times to create the compositions in Limoges enamels.

ENLEVAGE

Detail of no. 7

A technique where the white powdered glass is manipulated with a fine tool to expose the darker fired layer below. It was commonly used to delineate features in the face, anatomy, and drapery of figures or to impart additional lines to the composition. Sometimes there is evidence of where the pointed tool exited the white powder, indicated by the slight buildup of white at the end of each line in the fired enamel.

FLESH TONE

Detail of no. 19

To add warmth to the skin, Limoges enamelers used two techniques. The first was dependent on the underlying pre-fired enamel color, such as translucent mulberry or possibly mulberry opacified with tin oxide (see illustration for **paillons**). The white was then carefully modeled over this base color. Sometimes **oxide colors** were applied to enhance this subtle pink quality. In the second method, flesh areas were modeled in **grisaille** but often modified with oxide colors to create a more accurate skin tone.

GILDING

Detail of no. 29

The gilt decoration on Limoges enamels was prepared by mixing finely powdered gold with a binder. A brush was used to apply highlights to areas such as the hair, drapery, haloes, accents to the sky, and to larger areas of undecorated enamel. It was the last step used because it required the lowest firing temperature. The gold is not as durable as the enamel and is susceptible to abrasion and loss—often quite worn on Limoges enamels, it was sometimes repainted at a later date. In specular light, an imprint of the original gilt design in the enamel is visible, called ghosting; the surface is left matte from the fusing of the gold to the enamel.

GRISAILLE

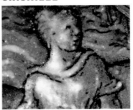

Detail of no. 36

A technique developed in the 1530s in which white areas are gradually built up over a dark ground through multiple applications of finely powdered glass and several firings. Grisaille has a very

painterly effect that allows for a full tonal range of grays. **Translucent enamels** or oxide colors can be applied on top to add color to these areas. This technique superseded the earlier method of Limoges enamel painting where the composition was dominated by dark lines applied to a pre-fired white ground and then colored with transparent enamels (see illustration for oxide color).

KILN

An insulated chamber that creates and maintains high heat. The first kilns were heated by wood or coal. Muffle boxes or arches of perforated iron or clay protected the enamel from soot and debris and allowed for even heating. Firing of enamels required a range of 1,292–1,652°F (700–900°C). Maintaining even temperatures within the kiln and visual inspection of the enamel were particularly challenging during the Renaissance. It was not until the nineteenth century that technological advancements allowed for improved visibility and more consistent temperatures.

OPAQUE ENAMELS

Opaque enamels block the transmission of light. When applied directly to the metal substrate or on top of another enamel, the layers underneath are not visible. White is the most common opaque color for Renaissance Limoges enamels. Tin oxide, present as small dispersed crystals within the glass, scatters light, reducing the translucency. Opaque enamels can be applied in very thin layers on a dark enamel ground, resulting in lighter shades of the color beneath, for instance in **flesh tones** and in grisaille.

OXIDE COLOR

Detail of no. 3

A powder used on enamels that has very little or no vitreous component. Often made from iron oxides, it is typically dark brown or a red earth tone. It was used to create thin dark lines under the transparent enamels on early Limoges plaques but was also applied as one of the last embellishments on the top surface of enamels: for example, the warm pink to red washes for **flesh tones** or the accents of blood on the Christ figure (see illustration for paillons).

PAILLONS

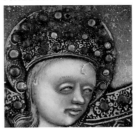

Detail of no. 1

Pieces of gold or silver foil placed under translucent enamels. The foils used for enameling are slightly thicker than metal leaf. In early Renaissance Limoges enamels, paillons are commonly placed below flowers or cabochons. A unique application can be seen in the double-tiered triptych (no. 7), where the small rectangular silver squares create reflective inclusions within the green and pink panels of Christ's tomb (see **enlevage**). The foil is adhered to a pre-fired enamel surface using a binder and then fired. For larger areas of foil, the metal was likely pricked with tiny holes first to allow air to escape during firing, minimizing air bubbles and ensuring proper adhesion of the foil to the enamel underneath. Transparent enamel is then applied on top and the enamel is fired again.

TRANSLUCENT ENAMELS

Detail of no. 19

Translucent enamels allow light to be transmitted. The layer beneath can be discerned and influences the appearance of the translucent color on top. For example, when applied onto a white ground, the translucent color will appear lighter than if it were on top of a dark ground. If applied over a reflective metal surface, such as copper, gold, or silver, a brilliancy is imparted to the enamel on top.

BIBLIOGRAPHY

Archives Nationales 1972
Coligny: protestants et catholiques en France au XVIe siècle. Exh. cat. Paris: Archives Nationales, 1972.

Bailey 2006
Bailey, Colin. *Building the Frick Collection: An Introduction to the House and Its Collections.* New York: The Frick Collection/Scala, 2006.

Baldry 1904
Baldry, Alfred Lys. *The Wallace Collection at Hertford House.* New York: Goupil, 1904.

Baratte 1993
Baratte, Sophie. *Léonard Limosin au musée du Louvre.* Paris: Réunion des musées nationaux, 1993.

——. 2000
Baratte, Sophie. *Les Émaux peints de Limoges.* Paris: Réunion des musées nationaux, 2000.

Bautier 1990
Bautier, Anne-Marie. "Le thème des Douze Césars dans les émaux peints de Limoges (XVIe–XVIIe siècles)." *Bulletin de la Société archéologique et historique du Limousin* 118 (1990): 64–105.

Bedos Rezak 1990
Bedos Rezak, Brigitte. *Anne de Montmorency: seigneur de la Renaissance.* Paris: Éditions Publisud, 1990.

Bellanger 1997
Bellanger, Yvonne, ed. *Le Mécénat et l'influence des Guises: actes du colloque organisé par le Centre de recherche sur la littérature de la Renaissance de l'Université de Reims et tenu à Joinville du 31 mai au 4 juin 1994.* Paris: H. Champion, 1997.

Boehm and Taburet-Delahaye 1996
Boehm, Barbara Drake, and Elisabeth Taburet-Delahaye. *Enamels of Limoges 1100–1350.* Exh. cat. New York: Metropolitan Museum of Art/Harry N. Abrams, 1996.

Bonnaffé 1874
Bonnaffé, Edward. *Inventaire des meubles de Catherine de Médicis en 1589.* Paris: A. Aubry, 1874.

Campbell 1983
Campbell, Marian. *An Introduction to Medieval Enamels.* London: H.M.S.O., 1983.

Caroselli 1993
Caroselli, Susan L. *The Painted Enamels of Limoges: A Catalogue of the Collection of the Los Angeles County Museum of Art.* Los Angeles: The Museum, 1993.

Crépin-Leblond 1995
Crépin-Leblond, Thierry, et al. *Le Dressoir du prince: services d'apparat à la Renaissance.* Exh. cat. Paris: Réunion des musées nationaux, 1995.

——. 2010
Crépin-Leblond, Thierry. *De la lettre à l'émail: Léonard Limosin interprète Ovide.* Exh. cat. Paris: Réunion des musées nationaux, 2010.

Dacos 1969
Dacos, Nicole. *La Découverte de la Domus Aurea et la formation des grotesques à la Renaissance.* London: Warburg Institute, 1969.

Emiliani 1960
Emiliani, Andrea. *Il Bronzino.* Busto Arsizio: Bramante, 1960.

Gatouillat 2011
Gatouillat, Françoise, Michel Hérold, et al. *Les Vitraux d'Auvergne et du Limousin.* Rennes: Presses universitaires de Rennes, 2011.

Gauthier 1972
Gauthier, Marie-Madeleine. *Émaux du moyen âge occidental.* Fribourg: Office du livre, 1972.

Grand-Dewyse 2011
Grand-Dewyse, Camille. *Émaux de Limoges au temps des guerres de Religion.* Rennes: Presses universitaires de Rennes, 2011.

Havard 1896
Havard, Henry. *Histoire de l'orfèvrerie française.* Paris: Librairies-Imprimeries Réunies, 1896.

Higgott 2011
Higgott, Suzanne. *Catalogue of Glass and Limoges Painted Enamels.* London: Wallace Collection, 2011.

Jollet 1997
Jollet, Étienne. *Jean et François Clouet.* Paris: Lagune, 1997.

Landau and Parshall 1994
Landau, David, and Peter Parshall. *The Renaissance Print: 1470–1550.* New Haven: Yale University Press, 1994.

Lightbown 1992
Lightbown, Ronald W. *Mediaeval European Jewellery: With a Catalogue of the Collection in the Victoria & Albert Museum.* London: Victoria & Albert Museum, 1992.

Marquet de Vasselot 1921
Marquet de Vasselot, J. J. *Les Émaux limousins de la fin du XVe siècle et de la première partie du XVIe: étude sur Nardon Pénicaud et ses contemporains.* Paris: A. Picard, 1921.

Maryon 1971
Maryon, Herbert. *Metalwork and Enameling: A Practical Treatise on Gold and Silver-smith's Work and Allied Crafts*. New York: Dover Publications, 1971.

Notin 2002
Notin, Véronique, et al. *La Rencontre des héros: regards croisés sur les émaux peints de la Renaissance appartenant aux collections du Petit Palais, Musée des beaux-arts de la ville de Paris et du Musée de l'Évêché de Limoges*. Exh. cat. Limoges: Musée municipal de l'Évêché, 2002.

Read 1902
Read, Charles Hercules. *The Waddesdon Bequest: Catalogue of the Works of Art Bequeathed to the British Museum by Baron Ferdinand Rothschild*. London: British Museum, 1902.

Ritchie 1939
Ritchie, A. C. "Léonard Limosin's Triumph of the Faith, with Portraits of the House of Guise." *The Art Bulletin* 21, no. 3 (Sept. 1939): 238–50.

Romier 1949
Romier, L. "Lyon et le cosmopolitisme: au début de la Renaissance française." *Bibliothèque d'Humanisme et Renaissance* 11, no. 1 (1949): 28–42.

Ross 1941
Ross, Marvin Chauncey. "The Master of the Orléans Triptych: Enameller and Painter." *The Journal of the Walters Art Gallery* 4 (1941): 8–25.

Schwahn 2014
Schwahn, Birgit. "Enamel Insert Restorations on Limoges Painted Enamels: A Study on a Remarkable Nineteenth-Century Restoration Technique with Particular Attention to the Original Paillon Designs." *Studies in Conservation* 59, no. 3 (2014): 161–79.

Sharratt 2005
Sharratt, Peter. *Bernard Salomon: illustrateur lyonnais*. Geneva: Droz, 2005.

Slitine 2002
Slitine, Florence. *Samson: génie de l'imitation*. Paris: Charles Massin, 2002.

Speel 1997
Speel, Erika. *Dictionary of Enameling*. Brookfield, VT: Ashgate, 1997.

Verdier 1967
Verdier, Philippe. *Catalogue of the Painted Enamels of the Renaissance*. Baltimore: Walters Art Gallery, 1967.

——. **1977**
Verdier, Philippe. "Limoges Painted Enamels." In *The Frick Collection: An Illustrated Catalogue, Volume VIII: Enamels, Rugs, Silver*. Text compiled by Philippe Verdier with Joseph Focarino, Maurice Dimand, and Kathryn C. Buhler. New York: The Frick Collection, 1977.

——. **1995**
Verdier, Philippe. "Limoges Enamels." In *The Taft Museum: Its History and Collections, Vol. 2: European Decorative Arts at the Taft Museum*, edited by Michael Conforti. New York: Hudson Hills Press, 1995.

V&A 1926
Victoria & Albert Museum. *A Guide to the Salting Collection*. London: Board of Education, 1926.

Vignon 2015
Vignon, Charlotte. *The Frick Collection–Decorative Arts Handbook*. New York: The Frick Collection in association with Scala Publishers, 2015.

——. **forthcoming**
Vignon, Charlotte. *The Duveen Brothers and the Market for Decorative Arts between 1880 and 1940* (working title). Paris: Mare et Martin, forthcoming.

Vincent 2012
Vincent, Clare. "Painted Enamels." In *The Robert Lehman Collection, Vol. XV: Decorative Arts*. New York: Metropolitan Museum of Art / Princeton University Press, 2012.

Wardropper 1991
Wardropper, Ian. "Le Mécénat des Guises: art, religion, et politique au milieu du XVIe siècle." *Revue de l'Art* 94 (1991): 27–44.

Williamson and Motture 2007
Williamson, Paul, and Peta Motture. *Medieval and Renaissance Treasures from the V&A*. Exh. cat. London: V&A Publications, 2007.

Zerner 2003
Zerner, Henri. *Renaissance Art in France: The Invention of Classicism*. Paris: Flammarion, 2003.

Zvereva 2002
Zvereva, Alexandra. *Les Clouets de Catherine de Médicis: chefs-d'œuvre graphiques du Musée Condé*. Exh. cat. Paris: Somogy, 2002.

——. **2008**
Zvereva, Alexandra. "La Galerie de portraits de l'Hôtel de la Reine." *Bulletin monumental* 166, no. 1 (2008): 33–41.

INDEX Page numbers in **bold** indicate illustrations and their captions

ACKNOWLEDGMENTS

We are delighted to publish this first book devoted to the Frick's Renaissance painted enamels from the Limoges region of France. This extraordinary collection illustrates the broad range of objects to which the luminous medium of enamel was applied in sixteenth- and seventeenth-century France—from secular objects, such as portraits and tableware, to objects with religious associations. The majority of enamels in the collection were purchased by Henry Clay Frick in 1916 from the estate of J. Pierpont Morgan. A year later, Frick converted his first-floor office into a French Renaissance-style gallery to showcase what is widely believed to be one of the most important groups of Renaissance enamels in the world.

This handbook is very much indebted to the renowned Limoges scholar Philippe Verdier, who catalogued the Limoges enamels in *The Frick Collection: An Illustrated Catalogue* (1974–92). For their invaluable contributions to the preparation of this book, I wish to acknowledge Charlotte Vignon, Curator of Decorative Arts, and Julia Day, Associate Conservator, who also wrote the glossary, along with the other members of the Frick's Conservation Department: Adrian Anderson, Brittany Luberda, Patrick King, and the head of the department, Joseph Godla. While other Frick staff members have been involved with this project, I would like in particular to single out Michaelyn Mitchell, Editor in Chief, and Hilary Becker, Assistant Editor, for their editing and supervision of the publication, and Michael Bodycomb for his splendid photographs, as well as Sarah Thein-Weber, Executive Assistant to the Director, and Blanca del Castillo, Administrative Assistant. I'm also grateful to several individuals outside the institution: Clare Vincent, Lisa Pilosi, Mark Wypyski, Juanita Navarro, Terry Drayman-Weisser, and Katharine Wood. The staff of the Frick Art Reference Library has, as always, been extremely helpful. Finally, I thank my wife, Sarah McNear, without whose support I would be lost.